THE WIRRAL
IN
50
BUILDINGS

LES JONES

AMBERLEY

For Thomas, Lucy, Orla and Maxwell

First published 2019

Amberley Publishing, The Hill, Stroud
Gloucestershire GL5 4EP

www.amberley-books.com

British Library Cataloguing in Publication Data.
A catalogue record for this book is available from the British Library.

ISBN 978 1 4456 8750 6 (print)
ISBN 978 1 4456 8751 3 (ebook)

Typesetting by Aura Technology and Software Services, India.
Printed in Great Britain.

Contents

Key

Introduction

The Wirral Peninsula is roughly rectangular, 18 miles long and on average 7 miles wide, although it stretches to 11 miles at its widest. It has been represented on maps of Cheshire as the tail of a hen or the spout of a teapot, both of which were snapped off when Edward Heath and his cohorts decided in 1974 that a thousand years of history were of less consequence than the expedient creation of the municipal county of Merseyside, ruthlessly tearing north Wirral away from its mother county of Cheshire.

The geographical boundary of Wirral is clearly defined to the east and west by the contrasting waterways of the rivers Dee and Mersey, the former wide and natural with sweeping views across to Wales, the latter a product of industry and commerce with differing but no less interesting views across to Liverpool and its hinterland of redundant docks. The northern boundary faces the Irish Sea but the ill-defined southern boundary travels across the Vale of Broxton through Blacon to Stanlow Point, further south than most people realise.

The Anglo-Saxon Chronicle mentions Wirheal, roughly translated as 'Myrtle Corner', bog myrtle being abundant at the time but now no longer found in the area. The origin of the division 'hundred' has been variously ascribed to a district furnishing 100 warriors, or more prosaically as an area containing 100 families or of 100 hides of land. Geologically, it is a plateau of Triassic sandstone from which many of the buildings in this volume were constructed. A broad valley lies between the west ridge of Grange and Caldy Hills, through Thurstaston Hill to the highest point in Wirral at 359 feet in Heswall, and the eastern ridge around Bidston, which continues south as far as Bebington.

Within these boundaries lie the disparate villages of the west and south of the Peninsula, and the built-up industrial areas of Birkenhead and Wallasey to the north-east. This varied topography provides the diverse range of buildings outlined in this book.

The Wirral Peninsula has not been unduly touched by the broad sweep of British history: no major land battles have been proven to have taken place on its sylvan pastures, no great historical events have unfolded within its clearly defined borders. Despite this, Wirral remains a unique and beautiful place to live in and to explore.

Within the Peninsula there are over 1900 listed buildings, thus providing a difficult task in selecting just fifty to represent the diversity to be found here. A challenge such as this provides a subjective, if informed, choice and this is

reflected in the variation of building types within this volume, ranging from the magnificent Grade I Hamilton Square through mansions, churches, lighthouses and pubs to the humble cottage of an eighteenth-century heath squatter. Each building has a story to tell through its architecture, history and character, with stories of philanthropy, technology, faith, civic pride and the occasional spectral apparition making an appearance.

Many of the buildings are open to the public and visitors are actively encouraged; others are privately owned and are not usually open to the public, although Wirral Council do have open days to some of the properties during the summer. I hope you enjoy my choices.

The 50 Buildings

The primary entrance into the Port of Liverpool is through the Rock Channel. The protection of this route has been of great importance to the nation, especially during times of war. When war broke out against France in 1779 and again during the Napoleonic conflict the need for a permanent fort on the Wirral side of the Channel became ever more critical. Two temporary batteries were set up, one near the Red Rocks and one on Perch Rock, but these were deemed inadequate, therefore an Act of Parliament was passed allowing the raising of funds for a permanent structure on Perch Rock.

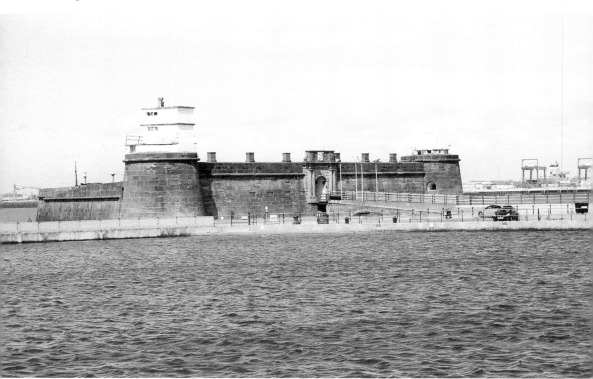

Fort Perch Rock from Marine Parade.

The resulting fort is largely the one we see today. Built between 1826 and 1829 of red Runcorn sandstone at a cost of nearly £27,000, it is between 24 feet and 32 feet high, with towers rising to 40 feet. It could accommodate 100 men and housed eighteen guns. The engineer charged with its construction, Captain John Sykes Kitson, designed the fort in the shape of a trapezium to both concentrate the firepower of the guns and to protect the structure from the force of the waves.

Although it is classed as the most important coastal-defence battery in the north-west, it has only fired its guns twice in anger. At the start of the First World War a Norwegian fishing vessel entered the Channel without permission, with two shots being fired at the unfortunate vessel as a consequence. Both missed. One ended up in the Crosby sandhills on the opposite side of the river where it was recovered and ended up in the officers' mess at Seaforth Battery, bearing the legend 'A Present from New Brighton'. The second salvo was in the Second World War under similar circumstances.

The fort was designed to withstand a siege and had its own water supply from a well in the basement. During the Second World War the whole structure was disguised as a tearoom with painted paths and 'Teas' written in large letters across the parade ground, and it was never marked on contemporary Ordnance Survey maps. Sold by the War Office in 1954, the fort has had various owners since and continues to be a major attraction in New Brighton.

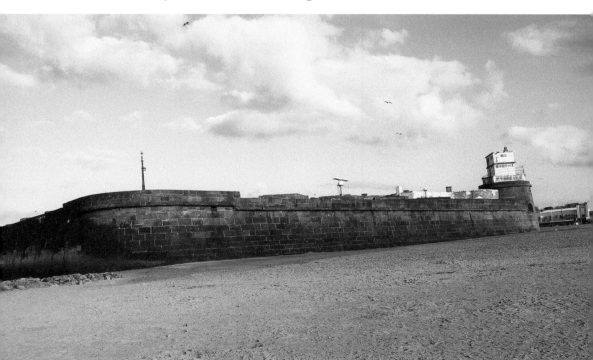

Fort Perch Rock from the shore.

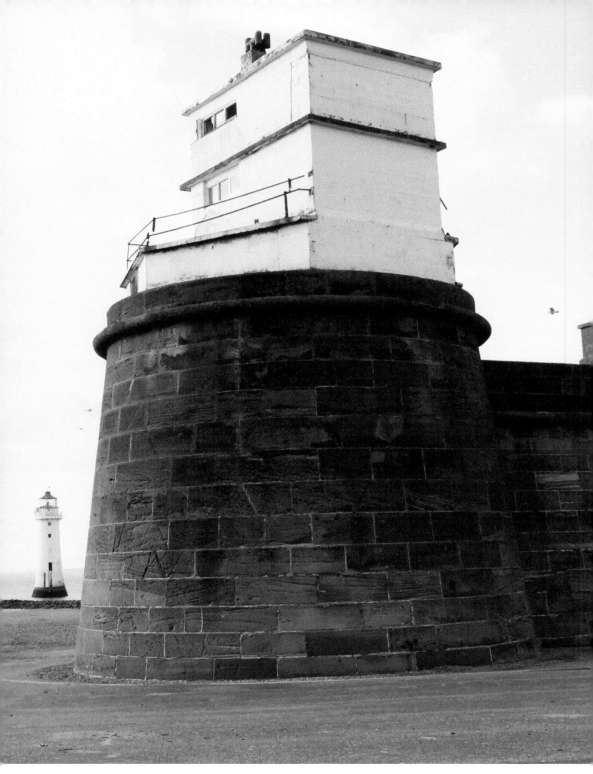

South-west tower.

2. Church of Saints Peter, Paul and Philomena, New Brighton

Known as the 'Dome of Home' due to its prominence as a landmark for merchant seamen returning to the Port of Liverpool after enduring the perils of the north Atlantic and the constant threat of U-boats during the Second World War, this well-known church and shrine has been giving spiritual guidance to the people of Wallasey since 1935. It is a Grade II listed building and is part of the diocese of Shrewsbury.

The site was originally occupied by a Victorian villa called Sandrock, one of the original mansions designed by James Atherton as part of his master plan for an exclusive resort to rival Brighton on the south coast. In 1911 it was purchased by the Sisters of the Cenacle, a Catholic organisation founded in France in 1826, but it was subsequently commandeered as a Red Cross Centre during the First World War, caring for nearly 1,000 soldiers. After falling into dereliction the house was bought by the Catholic Church and demolished to make room for the basilica we see today. This was mainly as a result of the efforts of Father Thomas Mullins, who was a tireless advocate for the shrine, basing the design on the Church of the Sacred Heart in Lisbon where he had studied as a seminarian at the English College there.

Like many places of worship the church has seen a decline in its congregation, and serious problems were found in the fabric of the building, leading to its

Dome from the south.

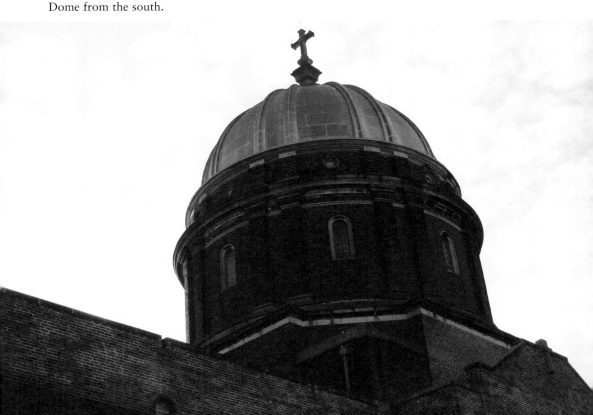

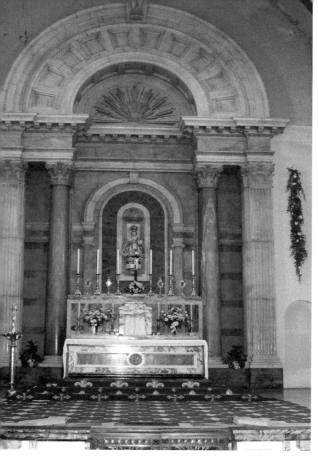

Left: High altar, Church of Saints Peter, Paul and Philomena.

Below: Nave, Church of Saints Peter, Paul and Philomena.

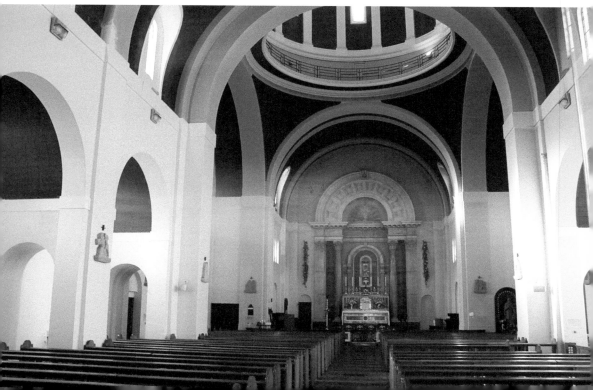

closure in 2008. After an appeal and a £170,000 grant from the Heritage Lottery Fund the church happily reopened in 2012.

The interior boasts a beautiful altar within an aedicule of pilasters and columns with a broad arch above. The overall effect is enhanced by the light that streams in through the dome above. This beacon deserves to be cherished both architecturally and spiritually.

3. St Hilary's Church, Wallasey

Located on one of the highest points in Wirral, and offering a sweeping view of the North Wirral coast and the mountains of Wales beyond, the site of St Hilary's Church has been hallowed ground since at least the sixth century. What is immediately striking is that there are two churches on this windswept plateau.

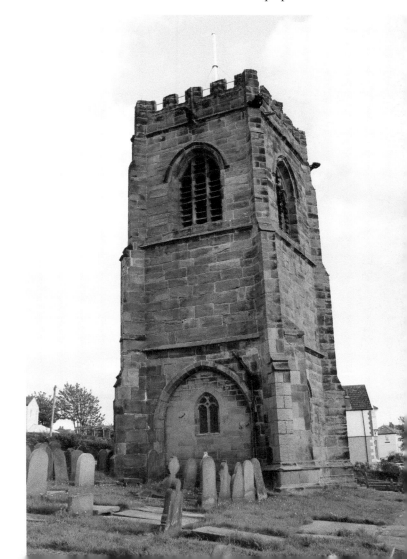

Tudor Tower of old
St Hilary's.

The current large parish church has been here since its completion in 1859, but the smaller tower to the south is of Tudor origin, constructed in 1530 during the reign of Henry VIII.

The tower is all that remains. The rest was consumed by flames in the early hours of Sunday 31 January 1857 when fires lit the previous evening to heat up the church set the nave alight. Parishioners had complained about the cold on the previous Sunday, which led to some overenthusiastic stoking by the caretaker. It was widely rumoured that the church had been used to store contraband brandy as the church burnt with a bright blue flame. The real cause, however, was burning fat from bacon joints left hanging in the tower – a common practice at the time.

The new church was built within two years of the disaster, using stone from the nearby quarry in Rake Lane. Cruciform in design, it has north and south transepts, both with rose windows, between which stands a large tower with a taller stair turret to the north-east. Within the church there is a huge font (the original Norman font was moved to the nearby St Luke's), elaborate reredos and some surviving stained glass by the pre-eminent Victorian designer Charles Kempe. Much stained glass was unfortunately lost during the Second World War.

The churchyard is approached through a quirky little lychgate and contains numerous interesting gravestones and monuments. There are also regular Heritage Open Days where a trip to the top of the bell tower is rewarded with splendid views.

St Hilary's Church from the east.

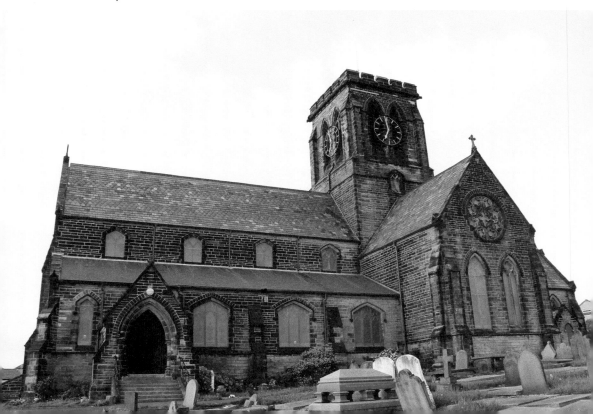

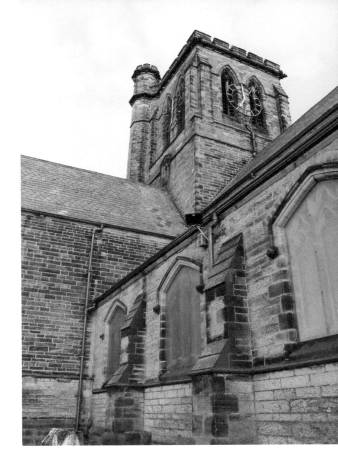

St Hilary's Tower and stair turret.

4. Old Grammar School, Wallasey

Grammar schools were set up from the fifteenth century to provide a free education to poor children of the parish, funded by philanthropists, charitable organisations and guilds. Wallasey Grammar School was founded with a philanthropic grant by Henry Meoles at nearby St Hilary's Church in 1595, when the first mention is made in the parish records. A second school was built through public subscription in 1799 and this is the building we see today.

Unfortunately many of the early records of the school were destroyed in a fire, but we know that in 1834 this small school housed no fewer than eighty-three pupils – sixty-five boys and eighteen girls.

These undoubtedly cramped conditions remained until the school moved again in 1864 to the former Back Lane, now St George's Road. The building then became a private residence, which was eventually acknowledged for its historic interest in 1952 when it was listed as Grade II.

The school marks the beginning of an access lane that leads to an old quarry, The Breck, which provided stone for many of the buildings in the vicinity and remains a popular recreation area to this day.

Above: Old Grammar School from Breck Road.

Left: Blocked window at the Grammar School.

5. Wallasey Town Hall

As Wallasey began to expand from a collection of small villages into a town of some consequence, the need for a building to house the various council offices became of greater importance. Premises were provided in Church Street near the junction of King Street, but these proved inadequate for the growing town and a new site became the cause of some heated debate among councillors. There were four sites vying to house the new Town Hall, namely Liscard (by the Capitol), New Brighton promenade, Rake Lane (near to the cemetery) and North Meade House in Egremont. The latter location won out after several months of lobbying and the casting vote of the mayor. Some of the reasons given were that the site was served by two tramway routes and the older and presumably wiser councillors preferred it. The design was chosen after an open competition by over 100 architects.

The foundation stone was laid by the reigning monarch, George V, on 25 March 1914, not at Egremont but a mile away in Central Park, Liscard, via an electrical signal. Its use as a Town Hall, however, was delayed by the outbreak of the First World War when it was used as a military hospital when over 3,500 men were treated. A plaque expressing the appreciation of the War Council remains on view in the main entrance area. It finally opened for its original purpose in November 1920, at a cost of £155,000.

The architectural historian Nikolaus Pevsner called it a strikingly monumental building for such an unmonumental town, and it certainly is quite grand. It is designed in the classical Beau Arts idiom, of Derbyshire stone with a tower worthy of Vanburgh, it is said. It is 180 feet high with four brooding figures and a stepped

Town Hall from Brighton Street.

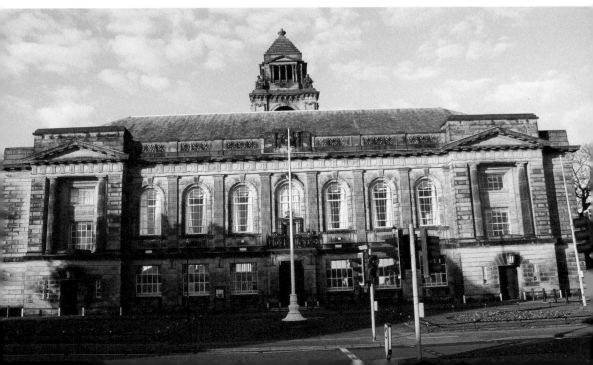

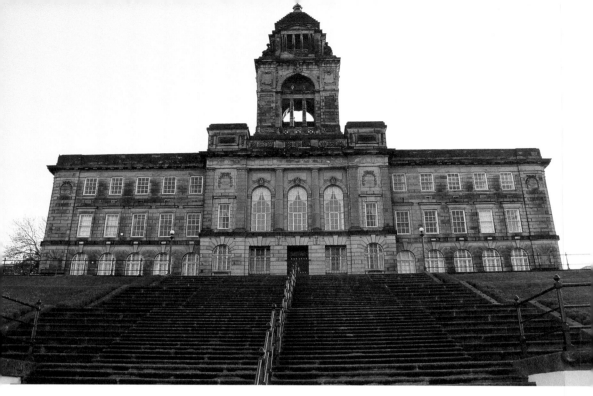

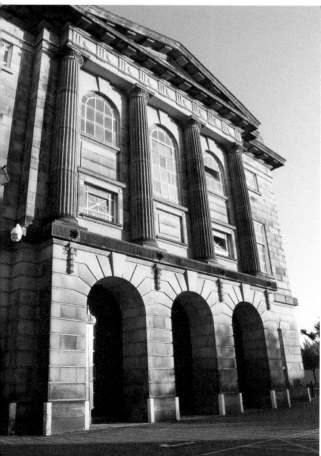

Above: Town Hall from Egremont
Promenade.

Left: Southern portico of the
Town Hall.

pyramid above. The building is best viewed, however, not from the street entrance but from the river, where there is an imposing cascade of steps down to the promenade. Inside, a grand staircase leads up to a magnificent council chamber overlooking the River Mersey.

6. Bird's House, Wallasey

Most travellers heading out of Wallasey towards the motorway at Poulton will probably be unaware that they have just passed the oldest inhabited house in Wallasey. Now hemmed in by large storage tanks, this sandstone cottage was once surrounded by green fields, sited on a ridge 50 feet above Wallasey Pool to avoid being flooded. There is some dispute as to the age of the cottage as the date stone above the door lintel is rather difficult to decipher – it is either 1627 or 1697. The original inhabitants' initials are also carved into the stone: 'W & MB' for William and Mary Bird – hence the name of the house. William Bird was a local yeoman and also the churchwarden for Poulton parish.

Constructed of sandstone from Storeton quarry, it was listed as Grade II as far back as 1952. It has single chamfered mullioned windows, tiny windows in the gable end facing Limekiln Lane and twin dormers to the north of the building. A smaller building called Birds Barn lay in front of the house, but this was pulled down for road widening. Although this historic property is modest in size, it contains no fewer than six bedrooms.

Bird's House, Wallasey.

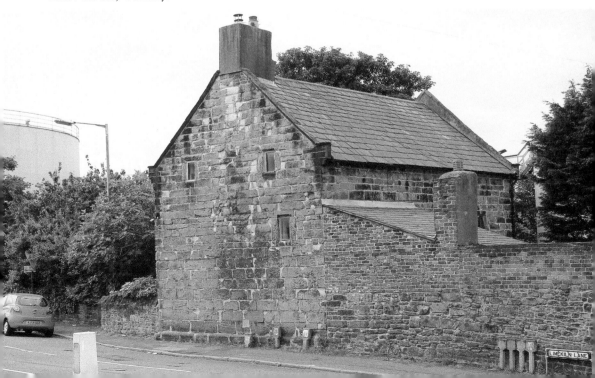

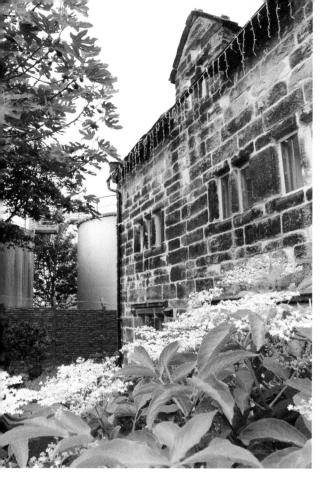

Dormer and mullioned window,
Bird's House.

7. Leasowe Castle

The earliest part of this rambling building, built up organically over four and a
half centuries, was built in 1593 by Ferdinando Stanley, the 5th Earl of Derby. It
is popularly thought that it was used as a stand to watch the Wallasey horse races,
but this seems unlikely as the racecourse was some 2 miles away on land now lost
to the sea. It appears rather too robust to have been a viewing lodge, the walls
being 3 feet thick with the entrance 5 feet above ground level. It is more likely to
have been a military strongpoint, especially as it was constructed just five years
after the Spanish Armada.

Four square towers were added by William Stanley, the 6th Earl, but the 7th Earl
unfortunately backed the wrong side in the English Civil War and lost most of
his fortune as a consequence, causing Leasowe Castle to fall into a ruinous state.
It must have looked a forlorn sight in the middle of the windswept plain, and
became known locally as 'Mockbeggar Hall'.

Salvation came when Lewis Boode, a West Indian planter and slave owner
bought the property and began renovations. When he died his widow continued to

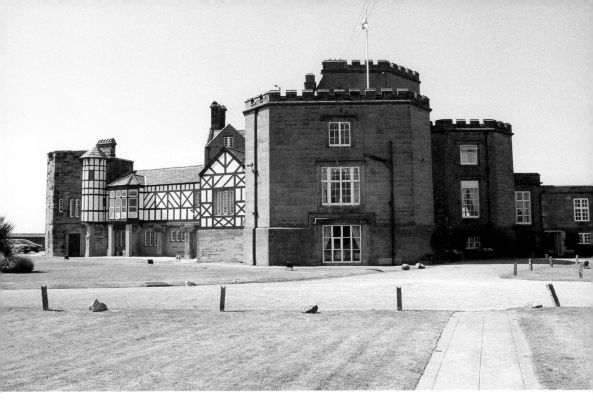

Above: Approach to Leasowe Castle.

Below: Leasowe Castle.

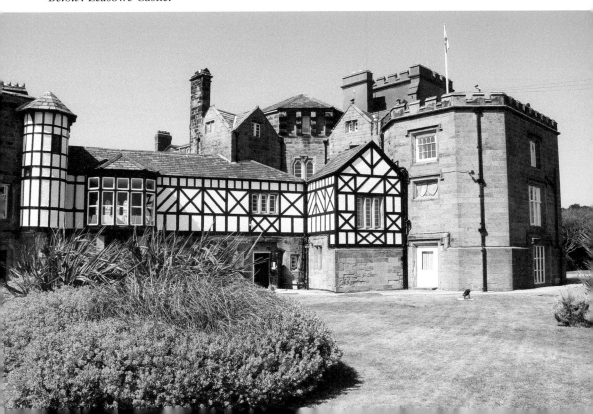

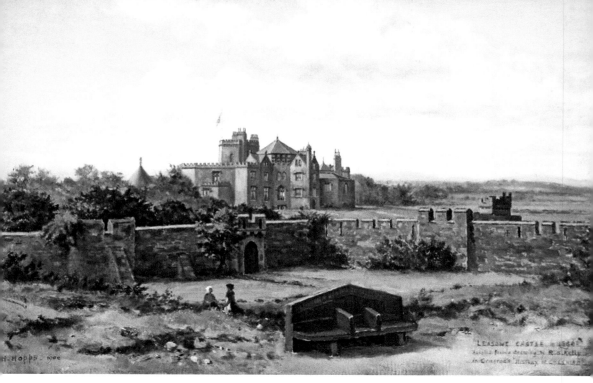

Leasowe Castle, 1896, by Harry Hopps.

make additions to the property, but she is better known for the assistance she gave to shipwrecked mariners off the North Wirral coast, using the castle as a receiving house and hospital. Her daughter married Colonel Edward Cust, who turned the castle into a hotel with only limited success. In 1911 it became a railwayman's convalescent home, which it remained until 1970 when Wallasey Corporation bought it and left it to rot. Its recent fortunes have improved, however, and it is now a popular hotel.

The interior contains panelling from the Star Chamber of the Court of Westminster, one of Colonel Cust's additions, together with a series of four large tapestries of a couple in bucolic settings. A further highlight is the so-called Battle Staircase, bearing the names of famous battles, the commanding general and the reigning monarch at the time. The castle is not handsome, but has character in abundance.

8. Birkenhead Priory

Birkenhead Priory was founded in around 1150 as a Benedictine abbey by Hamo de Massey of Dunham Massey in Cheshire. The priory held sixteen monks and was dedicated to St James the Great, patron saint of pilgrims. This was appropriate indeed as the Benedictine Order was required to care for and maintain ferries, and to assist travellers. As many pilgrims passed through this part of northern Wirral

on their way to the shrine of St Werbergh in Chester, the monks were kept busy ferrying the faithful across the River Mersey and giving succour within the walls of the priory.

A royal charter of 1318 by Edward II gave the monks the right to charge for their hospitality and a second charter granted by Edward III gave them the right to charge for the safe passage of travellers across the Mersey in perpetuity – this is why motorists going through the two Mersey tunnels today are charged on the Wirral side rather than the Liverpool end.

Less happy times came with the Dissolution of the Monasteries, when the priory was closed down and the monks sent away. The buildings were abandoned and much of the fabric was taken away for use in secular buildings nearby. The priory ruins were encroached by Victorian industry and separated from the shore by the shipbuilding yards of Cammell Laird's. Since 1896 various efforts have been made to stabilise and restore the site for posterity.

What is left of the priory is hauntingly picturesque, despite its forlorn location in the middle of an industrial estate. Large parts of the cloister garden remain intact and the chapter house is well preserved. This dates from 1150 and is the oldest building extant on Merseyside; it continues to be a place of public worship and contains much original Norman work. The scriptorium was built above the chapter house, and this dates from around 1375. A beautifully constructed undercroft and the remains of the Victorian St Mary's Church complete this important and historic site.

Birkenhead Priory chapter house.

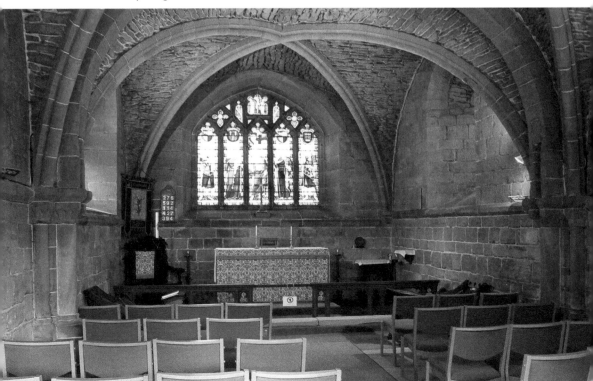

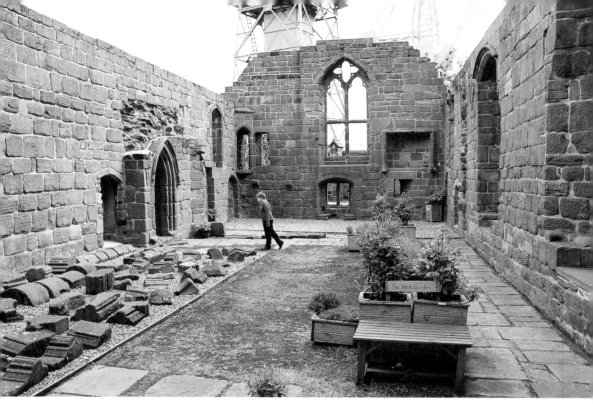

Above: Western range of Birkenhead Priory.

Below: Chapter house with the scriptorium above.

9. Woodside Ferry, Birkenhead

Situated directly opposite the Pier Head, Woodside Ferry commands a spectacular view of the Liverpool docks and the city centre. Although the only ferry still operating from Birkenhead, Woodside, was once one of many crossing points on the Wirral side of the Mersey, including Monks Ferry, which was operated by Birkenhead Priory. These rights reverted to the Crown upon the Dissolution of the Monasteries and the various crossing points came into private ownership by local landowners.

Woodside Ferry became busier in the eighteenth century due to an increase in stagecoach traffic from Chester and subsequently benefitted from the meteoric rise in the importance of Birkenhead from the 1820s, so much so that the town commissioners took over the running of the ferry from 1842. They built two slipways and a small lighthouse on a promontory to the north, which can still be seen today. A floating landing stage was constructed in 1861 and, with continued growth, other transport centres were constructed to the west, namely Woodside railway station and a tramway terminus, which became the bus station in the early 1900s. A large lairage was built in 1879, which processed live cattle from the United States until refrigeration brought an end to the movement of live animals.

Traffic using the ferry began to decline in the 1930s after the first Mersey road tunnel was opened, with the area gradually losing its importance as a transport hub. The grand Victorian railway station was demolished in 1967 and the status of the bus station was diminished.

Nonetheless, there is still much to see. The booking hall of 1864 is a listed building and now houses a cafeteria, which retains many of the original fittings.

Woodside, *c.* 1932.

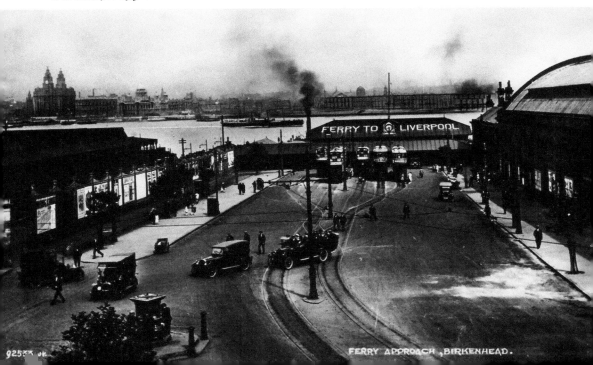

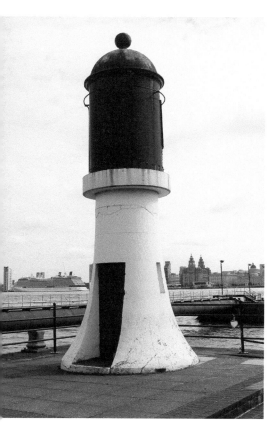

Above: Ticket office at Woodside Ferry.

Left: Woodside Ferry Lighthouse.

Nearby is a full-sized model of *Resurgam*, an early submarine that was tested for seaworthiness in Birkenhead Docks, and in 2008 a German U-boat was put on display to the south of the ferry buildings. Sunk by British bombers in the last month of the Second World War in Europe, it lay off the coast of Denmark until salvaged in 1993 and moved to Birkenhead.

10. Hamilton Square, Birkenhead

Commissioned by William Laird and designed by Edinburgh architect James Gillespie Graham, Hamilton Square was built on a grand scale, as befitted a boom town with great ambitions. It was to be the centrepiece of a gridiron layout of wide boulevards, lined with large stone-built villas, churches and public houses and other amenities. The long straight roads were laid out, but due to an unexpected recession this grand vision was pared back and only a few of the houses were constructed.

Named in honour of William Laird's mother, the square was started in 1825 with the houses at the north end of the east side, including what is now No. 63, Laird's own house. They are built of stone from nearby Storeton Quarry with three main storeys and a further storey above a cornice. The doorways are pilastered and fine

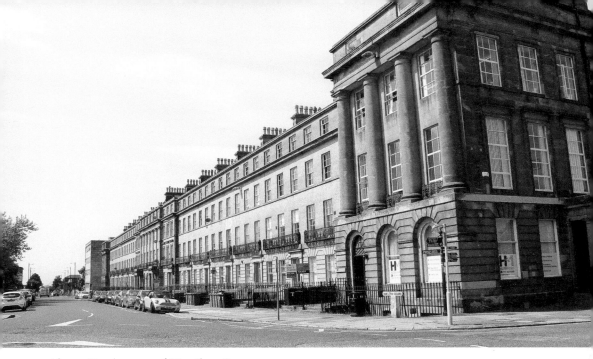

Above: North range of Hamilton Square.

Below left: Stairwell at No. 62 Hamilton Square.

Below right: Tuscan doorcase at Hamilton Square.

iron balconies run along the first floor beneath a rusticated ground floor. The ends are adorned with rows of Doric columns and the centre of each block is raised forward and enhanced with Doric pilasters. All of these houses are Grade I listed.

The central gardens were originally private, with each resident having a key. At the crossing of the diagonal pathways an Eleanor Cross was erected in 1905 in memory of the recently deceased Queen Victoria. A statue of John Laird, the son of William and Birkenhead's first Member of Parliament, originally graced the space in front of the Town Hall, but was exiled to the opposite side when the cenotaph was constructed.

The one jarring note is at the north-west corner of the square. A church originally stood on this site, but was unfortunately bombed during the Second World War. Its eventual replacement was a hideous slab thrown up for the council in the 1960s, a dire decade indeed for lovers of decent architecture. What Laird and Graham would have thought of it is anyone's guess.

11. Hamilton Square Station, Birkenhead

The world's first under-river railway linked Liverpool to Birkenhead beneath the River Mersey, with Hamilton Square being the first station on the Wirral side, with further stations at Central and Green Lane. Work started in 1879 and the station was completed in 1886. To reach the level of the tunnel, the engineers had to dig down over 100 feet below Hamilton Street. At such a depth the platforms could only be accessed via the use of lifts, the power for which was provided by water

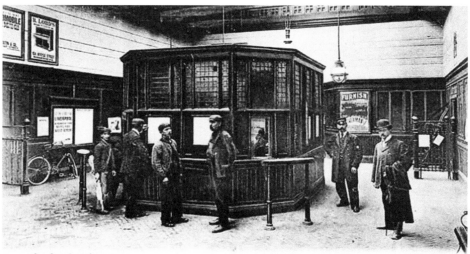

Birkenhead. Booking Hall, Hamilton Square Station.

The Wrench Series, No. 1511

Station booking hall, *c.* 1905.

pressure forced down from the large tower that still stands above Hamilton Street today. As with all Victorian architecture, the tower was built as an ornament to the landscape, looking rather like an Italian campanile with arched windows and a series of cornices and machicolations, all in red brick and terracotta. Although it no longer serves its original function, the tower remains – it was felt that it would be too difficult to knock down. The ornate canopy outside the entrance also thankfully remains.

The original mode of traction was steam, which proved very uneconomical, requiring more boilers to run the pumps, ventilators and lifts than for the locomotives themselves. Passengers also complained about the pungent odours from the action of steam on the sulphurous rock in the tunnels. Luckily, in 1903 the American G. W. Westinghouse arrived on the scene and electrified the line at his own expense. At this time the sign still gracing the tower – 'frequent electric trains' – was erected.

Further down Hamilton Street is a rather gaunt red-brick building, which still houses one of the three beam engines that pumped water out of the Mersey Railway Tunnel. The Grasshopper, as it was known, pumped water from the tunnel at an astonishing rate of 3,500 gallons per minute and was in use for seventy years until superseded by electric pumps.

The line proved extremely popular with tourists and workers alike, and the line was extended through to Rock Ferry in the south and West Kirby to the west. It remains a favoured mode of transport across the river to this day.

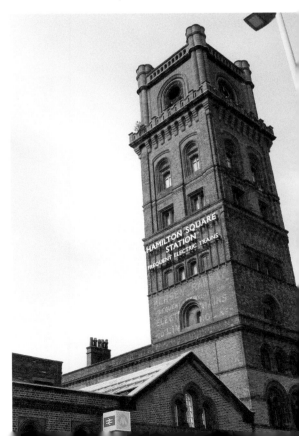

Above: Terracotta arches, Hamilton Square station.

Right: Hydraulic tower at Hamilton Square station.

12. Birkenhead Town Hall

The original 1825 designs for Hamilton Square by Gillespie Graham had always included provision for a Town Hall to the east of the square, but the site was not to be filled for over fifty years as constant delays and disputes among the interested parties thwarted any substantive progress. In 1877, Birkenhead became a borough with a mayor, fourteen aldermen and forty-two councillors representing the nine wards, which made the need for a Town Hall worthy of Birkenhead's ambition ever more pressing. Finally, in 1883 the foundation stone was laid and work began in earnest. Designed by local architect Christopher Ellison after winning a competition with over 100 designs, the work was complete by 1887 and was officially opened by Birkenhead's first Member of Parliament, John Laird, with over 5,000 people in attendance.

Postcard of the Town Hall, *c.* 1900.

Loosely based on Bolton Town Hall, the building was constructed of marble, Storeton stone and Scottish granite, at a cost of £43,000, in an English classical baroque style. The front has nine bays with a central portico containing six unfluted Corinthian columns and stairs descending on either side, with a rusticated ground floor. The clock tower is 200 feet high, the clock being started in 1886 by Elsie Laird, daughter of the mayor. Just fifteen years later a disastrous fire destroyed the original clock tower and it was rebuilt to a different design by Henry Hartley.

The interior contains a magnificent staircase with ornate metal balusters that leads to a half-landing with a stained-glass window by Gilbert Gamon representing Edward I's visit to Birkenhead Priory in 1277. The Assembly Rooms, Council Offices and Concert Room retain many of their original fixtures and although no longer used for most official business by Wirral Council, the Magistrates' Court and Registry Office remain. For a short period it housed the Wirral Museum, but this has since closed and it awaits a role that better suits its grandeur.

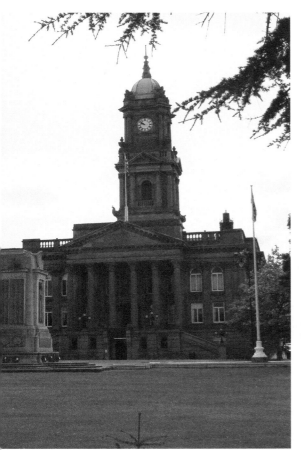 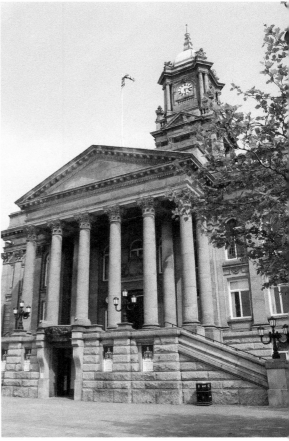

Above left: Birkenhead Town Hall.

Above right: Entrance portico to the Town Hall.

13. Cammell Laird Shipyard, Birkenhead

In 1824, William Laird established a boiler works at the edge of Wallasey Pool where he was joined four years later by his son John. The enterprise was such a success that they began to build cargo lighters and other small boats, the first named craft being the *Lady Lansdowne*, a paddle steamer built in 1833. Further expansion warranted a move to the banks of the Mersey where Laird's began to build larger vessels, including the famous and controversial *Alabama* in 1862 for the Confederate Army during the American Civil War, the *Ma Robert* for Dr Livingstone for his trip down the Zambezi, and *The Birkenhead*, made famous when it sank for the women and children first policy, which became known as the Birkenhead Rules.

In 1903, Laird's joined forces with a Sheffield steel company, Charles Cammell and Co., and as Cammell Laird's they oversaw the construction of thirty fighting

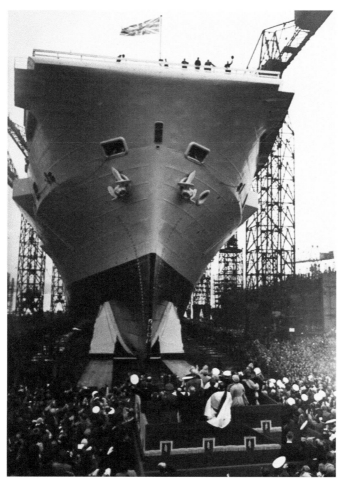

Launch of HMS *Ark Royal*.

ships during the First World War. During the interwar years they constructed many more famous and groundbreaking vessels: *Fullager*, the world's first all-welded ship; *Mauritania*, built for Cunard in 1938, the largest ship built in the UK to that date; and the mighty *Ark Royal*, also built in 1938 and Britain's first purpose-built aircraft carrier. Cammell Laird's played a vital role during the Second World War, with 106 further ships being built at an average rate of one every twenty days.

Over 1,300 vessels have been built at the yard, from mud punts to liners, with the last major launch being *Campbeltown*, a Royal Navy frigate, on 7 October 1987.

The yard had been nationalised in 1977 as part of British Shipbuilders by the Labour government, but was subsequently privatised again in 1986 as part of VSEL, before going into receivership in 2001. The famous name was acquired by Northwestern Shiprepairers and shipbuilding returned when an order was placed for an Irish car ferry. More orders have come in since, including, in 2014, a contract to build a research ship for the Antarctic Survey, named the RRS *Sir David Attenborough*, but better known as RRS *Boaty McBoatface*.

Cammell Laird Shipyard looking upstream.

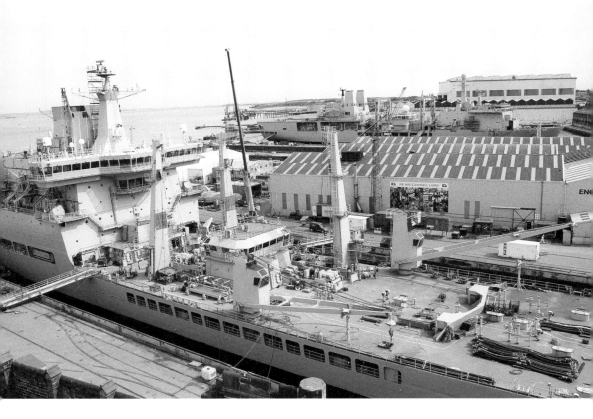

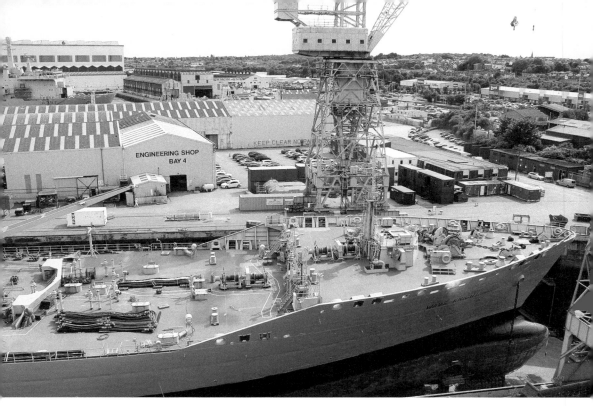

View of Laird's from St Mary's tower.

14. Birkenhead Park Main Entrance

The main entrance to one of the first municipal parks in the United Kingdom is appropriately grand. While it is well known that the park was designed by Sir Joseph Paxton of Crystal Palace and Chatsworth fame, the grand entrance to the park was actually designed by Gillespie Graham, the architect of the Grade I listed Hamilton Square. When built, the entrance marked the edge of the town of Birkenhead and must have made an even greater impression than today.

The frontage measures 125 feet across and incorporates lodges on both sides of the structure, with pedestrian archways either side of the large 18-foot-tall central arch. Six pairs of unfluted Ionoc columns enhance the main elevation, with a further two sets on the park façade. The arms of Birkenhead can be seen above the central arch and were also on the ornamental gates that once adorned the structure.

Similar in size to the far more famous Marble Arch and Arc de Triomphe in Paris, it was completed in 1846; however, the park was not officially opened until the following year when the grand opening was combined with the opening of the docks in the town.

Further smaller lodges stand at the entrances to some of the lesser pathways and are based on various forms of classical architecture, such as the Gothic Lodge,

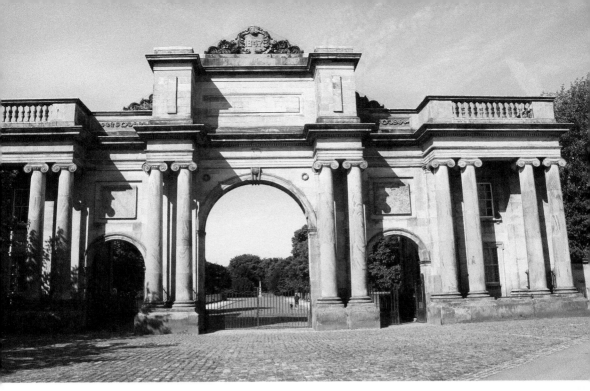

Above: Birkenhead Park main entrance.

Right: Central arch of the main entrance.

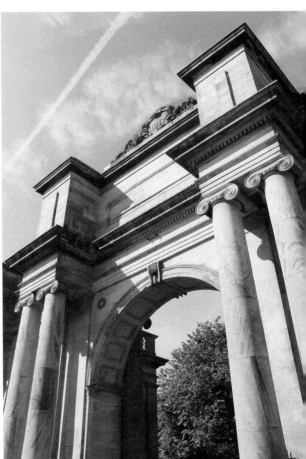

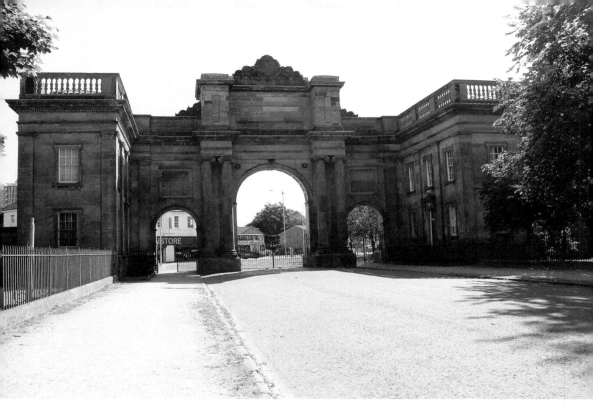

Entrance from the park.

the Norman Lodge and the magnificently restored Italian Lodge. Hills were created by excavating an upper and lower lake, with a rockery, boathouse and Swiss bridge enhancing many of the vistas. Much of the periphery, around a third of the total acreage, was taken by large Victorian villas, which were sold off to pay for the construction of the park, although much of the land remained unsold for many years.

The main entrance stands in mute testimony to the boundless energy and vision of our forebears and remains one of the boldest examples of Victorian architecture anywhere on Merseyside.

15. Bidston Hall

Standing on a ridge of yellow sandstone from which it was built, Bidston Hall projects an aura of brooding melancholy, which is reflected in much of its history. Built in 1595 by William Stanley, 4th Earl of Derby, as a hunting lodge from which deer were stalked on nearby Bidston Hill, it was subsequently expanded to become a suitable residence for the Stanleys from the beginning of the seventeenth century. The Stanley family had a massive fall from grace after backing the wrong side in the English Civil War and the ownership of the hall changed hands when Sir Robert Vyner, a London goldsmith and local landowner took over, restoring

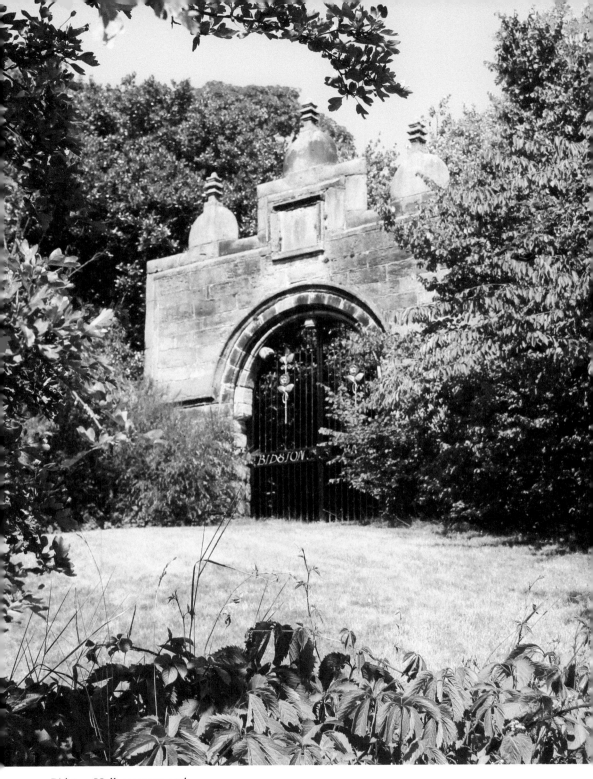

Bidston Hall entrance arch.

much of the fabric that had been neglected. This is a common theme with the hall as subsequent owners have moved in and made renovations, especially the Faulkners in the 1960s.

Bidston Hall was graded as II* in 1950 and consists of two parallel longitudinal gables. It has a symmetrical façade with an eye-catching two-storey semicircular bow porch and sets of mullioned windows at first-floor level. There is an unusual central loggia to the rear of the property with more mullioned windows. The interior consists of a large central hall with side wings off, and it boasts an extensive range of cellars.

There have been many stories down the years of strange goings-on and hauntings within the hall, especially so in the numerous bedrooms and within the cavernous cellar, so much so that the TV programme *Most Haunted Live!* paid a visit in January 2009 as part of a series on haunted Merseyside. Many unexplained incidents and sightings seem to be linked to a particularly gruesome murder in the nineteenth century when five members of the Williams family were murdered and buried in a cellar near to the hall. The culprit turned out to be the father, who was even linked to the infamous Jack the Ripper at one time.

Bidston Hall.

16. Bidston Windmill

Bidston Hill is over 200 feet above sea level on a windswept ridge on the eastern side of the Wirral Peninsula, and was therefore an obvious choice for siting a windmill. There has been a mill here since at least 1596 – evidence of this is visible as a series of small holes adjacent to the present windmill. These earlier mills were of the peg or post variety whereby the whole structure was moved to face the wind, rather than the current tower mill, which only has the top half movable. The extant mill was built around 1800 to replace the previous one, which was burnt down when the sails or sweeps broke free, causing friction and subsequent fire – a frequent occurrence, it would seem, as the current mill has been damaged by fire in 1821 and again in 1839. It has been calculated that uncontrolled sails can reach a speed of 60 miles per hour.

The mill last produced flour in 1875, partly because it was difficult to get carts up the steep inclines. The last miller was a Mr Youds. Bats now roost in the mill in winter, but it can be visited in the summer during weekend open days.

Below left and right: Bidston Windmill.

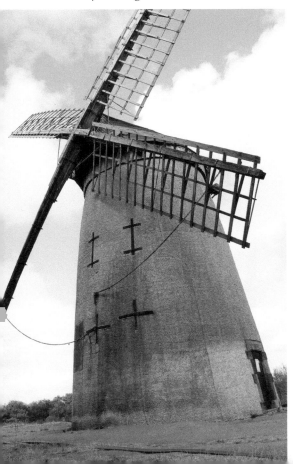 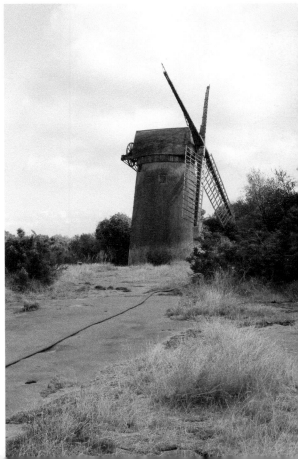

17. Bidston Observatory

Built in 1866 by the Mersey Docks and Harbour Board for astronomical and meteorological observations to aid shipping, Bidston Observatory was positioned well away from the pollution that had caused the closure of the first observatory at Waterloo Dock. Constructed from rock-faced stone, it consists of two domed towers designed for telescopes – very heavily constructed so as to minimise vibrations. The original layout had an attached library and chart room at one end with a house providing for the director of the observatory at the other. A lighthouse was also contained in the same enclosure and was used as a triangulation point with a lower light at Moreton shore, which assisted shipping entering the deep water channel from Liverpool Bay.

More accurate weather forecasts and tide level predictions could be prepared under the same roof. The machinery produced accurate tide tables for the entire world, both past and future, and was even used to measure the changes to the width of the Atlantic Ocean.

Furthermore, the observatory also sent an electronic signal through to Morpeth Dock in Birkenhead, which set off a cannon at precisely one o'clock

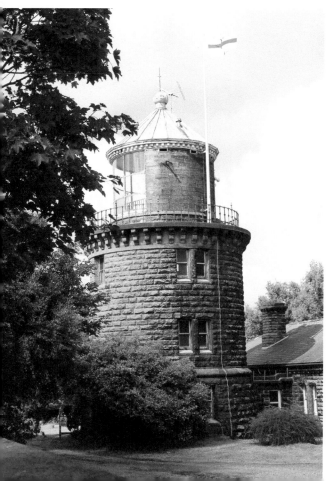

Bidston Lighthouse.

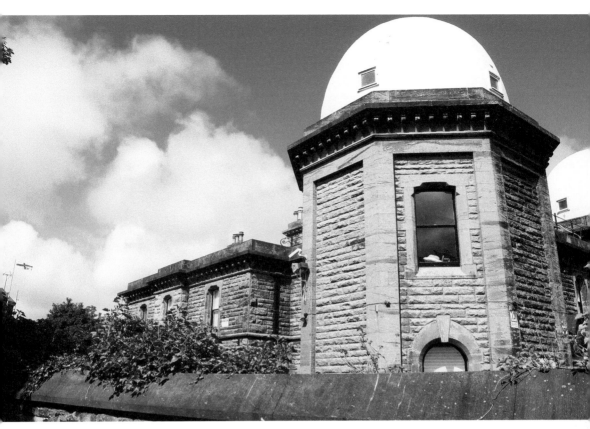

Above and below: Bidston Observatory.

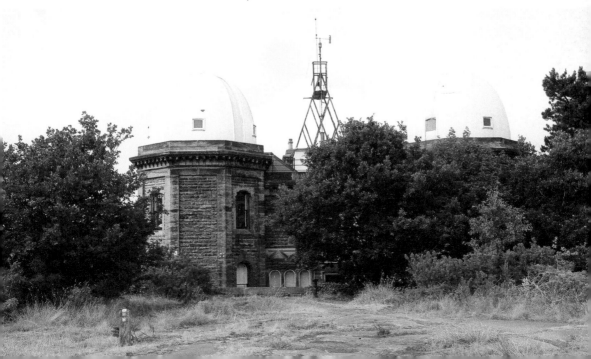

so that mariners could check their chronometers, accurate timekeeping being vital to establishing longitude and therefore safe navigation for vessels at sea. The institution also calibrated chronometers from the cellars of the building under controlled conditions of temperature and seismic vibrations.

John Hartnup was the original director and leading force behind the construction of the observatory and was succeeded by his son John Jr, who tragically died while taking meteorological observations from the roof. However, the Hartnups' vision has made the oceans a safer place for all seafarers and were instrumental in accurately predicting the tides for D-Day in 1944. There is a degree of uncertainty regarding the site since the institute moved away; it is hoped that a suitable purpose can be found for this historic and important group of buildings.

18. Tam O'Shanter Cottage, Birkenhead

This cottage is thought to have been built by a heath squatter over 300 years ago. By the 1830s it was being occupied by a Scotsman named Richard Lea who happened to be a master stonemason. He used his skills to carve a stone slab into the shape of a horseman being pursued by witches, a reference to a poem by the Scottish bard Robert Burns that relates the story of a man who had irritated the local coven. He was being chased by them but planned his escape by riding over a bridge as he knew the witches could not cross running water. They had to be content with grabbing his unfortunate horse Maggie by the tail. The poem was called 'Tam O'Shanter' and the cottage has been known by this name ever since.

Right and opposite below: Tam O'Shanter Cottage.

The cottage has had a chequered history, having been badly damaged and threatened with demolition on numerous occasions. After a particularly severe fire in 1975 it was only saved from destruction by the timely intervention of the Birkenhead History Society who renovated it and opened it as an urban farm, which has proved hugely popular.

19. Mayer Hall and Pennant House, Bebington

These two disparate buildings are best viewed together as they are both linked to Joseph Mayer, a nineteenth-century antiquary, collector and philanthropist. The sixth of eleven children, Mayer was born in Staffordshire into a wealthy family. He moved to Liverpool where he trained as a goldsmith before moving again, this time to Bebington where he purchased a small farmhouse, which he set about renovating. He named it Pennant House after Thomas Pennant, a Victorian naturalist, eventually adding the distinctive clock tower in 1870 along with a second block of buildings with a viewing tower at the rear facing what became Mayer Park.

These extensions were primarily built to house a library containing 20,000 volumes, which he opened for the benefit of the people of Bebington. This was just one of a number of philanthropic acts undertaken at this time, others included the provision of gas and water for the town, the founding of numerous local clubs, and the setting up of the 4th Cheshire Rifles, of which he was commander for ten years. He also established an art gallery and museum to house his large collections of objets d'art, including sculpture and paintings from his travels abroad. The available space was soon full, however, and he demolished the original barn in 1878 to make room for Mayer Hall, a purpose-built two-storey building containing an area for exhibits on the first floor with a special lecture theatre on the ground floor.

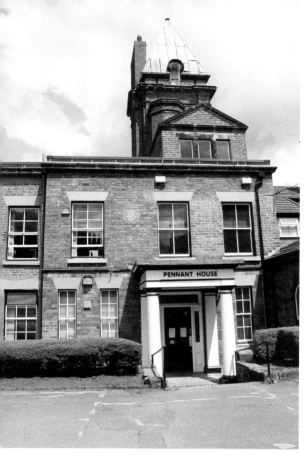

Left: Pennant House.

Below: Mayer Hall and clock tower.

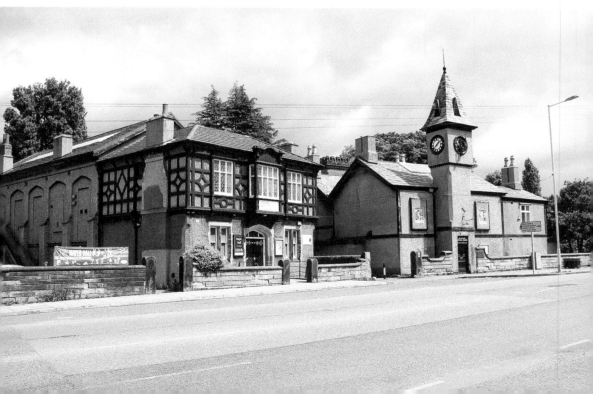

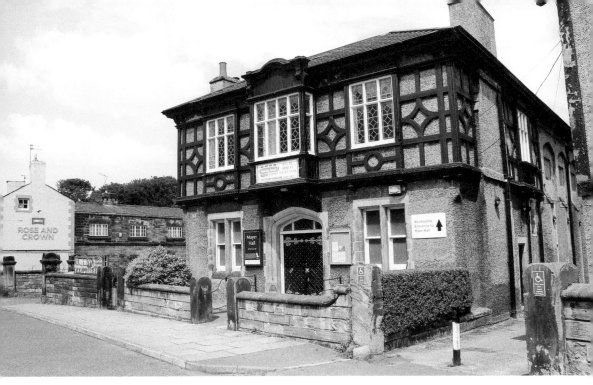

Mayer Hall.

Joseph Mayer set up a trust shortly before his death to provide local amenities for the people of Bebington. One element of the trust was to grant money for the provision of lectures at Mayer Hall, which still take place today. A blue plaque, one of only fifteen commissioned for the Merseyside area, is positioned to the rear of Pennant House in honour of Joseph Mayer, and there is a statue of the great man in St George's Hall, paid for by grateful subscribers to Mayer's library.

20. Arrowe Hall

At over 425 acres, Arrowe Park is the largest public park in the United Kingdom, big enough to contain several football pitches, bowling greens, a golf course, vast acres of green fields, children's play areas, a pub and a 1,000-bed general hospital, which periodically chews great slices out of the greenery for additional parking space. It is hard to contemplate that all this was once the private grounds to Arrowe Hall, the country estate of John Ralph Shaw, a fabulously wealthy shipowner and slaver who also owned most of nearby Greasby. Having served as Mayor of Liverpool for six years, he retired to the healthier air of the Wirral Peninsula. As well as buying large tracts of land he also built a substantial mansion for himself and named it Arrowe Hall, after the small village nearby – Arrowe being Norse for 'summer pasture'. This is the house we see today.

It was built in the Elizabethan style between 1835 and 1844 from beautiful honey-coloured stone, with extensions added in 1864 and 1876. These additions

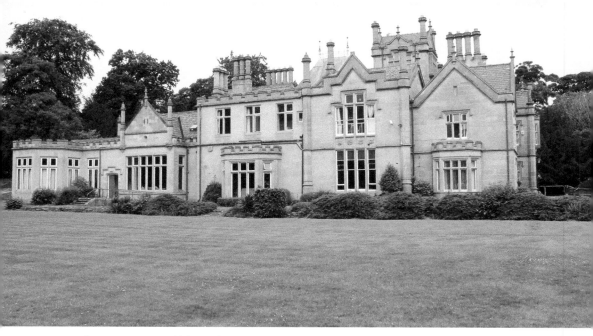

Above: Arrowe Hall from the park.

Below left: Main entrance to Arrowe Hall.

Below right: The central hall.

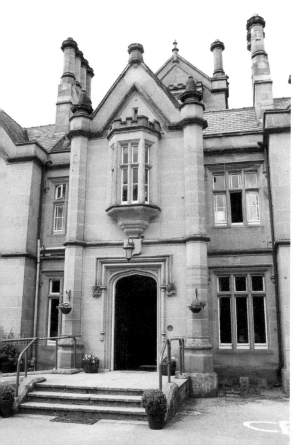

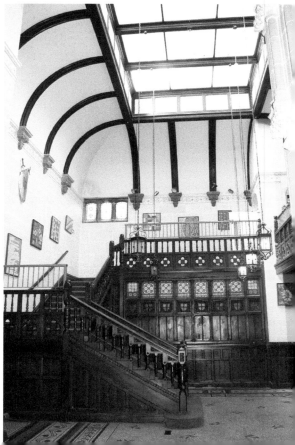

were needed to display the many hunting trophies brought back from around the globe by a descendent of Ralph Shaw, one Otto Shaw. He filled the place with yaks, moose heads, leopards and a myriad of other unfortunate beasts, not to mention birds of every ilk. He was also an avid collector of pottery, glass and other souvenirs from his travels, which all found a home at Arrowe Hall.

The property eventually came into the hands of Lord Leverhulme, who sold it to Birkenhead Corporation in the 1920s as a public park for the benefit of the people of Birkenhead. The hall became a convalescent home and remained so for many years and is now a private care centre.

Within the grounds of the hall the World Scout Jamboree was held in 1929 to celebrate the twenty-first anniversary of the scouting movement. The scouting movement was founded by Lord Baden Powell in 1908 at the old YMCA building in Grange Road, the upper floors of which survive above a branch of Primark.

21. Holy Cross Church, Woodchurch

Hidden away in the south-west corner of a large housing estate in leafy tranquillity is the ancient Holy Cross Church. This may have been a Saxon place of worship, but a church was first mentioned on this site in 1093 in a confirmation charter of Hugh Lupus. The oldest extant parts, however, are a wall that was cut through by a fourteenth-century arcade, and a few sculptured grave markers and miscellaneous fragments. The current church takes the form of a central nave with wide aisles to the north and south, a chancel and a tower. Entry is gained through a small lychgate and a line of yew trees to the south porch with its heavily studded Tudor door. This leads to a small vestibule with the remains of a holy water stoup. The south aisle was created in the fourteenth century but remodelled in the sixteenth century, making it much older than the north aisle.

Within the chancel are four stalls containing magnificent carvings and poppy head finials. The carvings include acrobats or wrestlers, oak leaves, acorns, heraldic devices and pelicans, which are Christian symbols representing a self-sacrificing parent and much used in heraldry. There is an altar in the nave, behind which is a richly carved rood screen leading through to the chancel.

The outside face of the chancel inclines to the north, giving it the appearance of what is known as a weeping chancel. The prominent feature on the exterior, however, is the fourteenth-century west tower. Made of a darker stone than the main body of the church, it is of two distinct stages, with bell openings, battlements and two extremely large diagonal buttresses added in 1675, which give it a rather odd appearance. The entire tower was refaced at the same time. Although the church has seen many additions and restorations over the years, it has luckily escaped the dubious attentions of well-meaning Victorian restorers who often destroyed fabric of great antiquity.

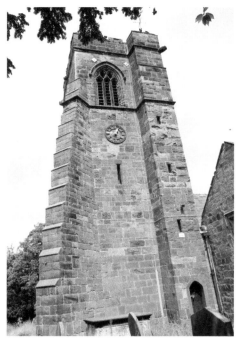

Above left: Buttressed Tower of Holy Cross.

Above right: Tudor door in the south porch.

Below: South nave aisle and porch.

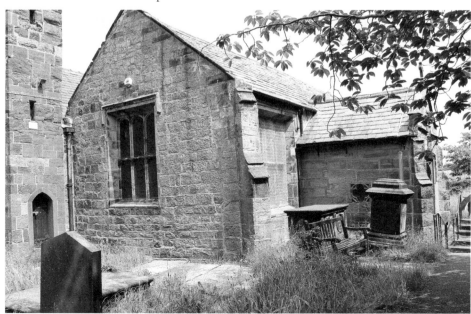

22. St Andrew's Church, Bebington

Described as the finest old church in Wirral, the Grade I listed St Andrew's Church stands on the site of a pre-Roman church. No trace of this remains, but there are parts of the existing fabric that may be pre-Conquest, notably a line of weathered stone at the base of the south aisle. The church was extended by the Normans around 1120–30, remodelled in the fourteenth century and largely rebuilt in Storeton stone between 1511 and 1528. Having been owned by the Abbey of St Werburgh in Chester for much of its life, St Andrew's passed into private hands after the Dissolution of the Monasteries around 1536, with the Stanleys of Hooton taking possession.

The tower and distinctive spire were raised in the fourteenth century, but although it gives the appearance of antiquity the wooden lychgate is little more than 100 years old. The final major restoration was in 1846–47 when the church took on its current form. Much use was made of the original stone, therefore avoiding the fate of many old churches during the Victorian period of overzealous restoration. The original roof, however, was entirely lost in an 1897 renovation. Another loss occurred as late as 1968 when the churchyard was 'tidied up', completely ruining any semblance of scenic charm it once had.

The interior of St Andrew's does not disappoint. Local historian David Randall thought that the church was so impressive because it is a 'splendid amalgam of building styles, from the simple Norman arcades to the magnificent Tudor work in

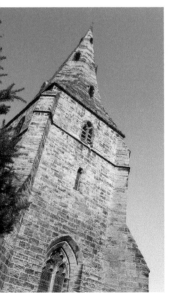 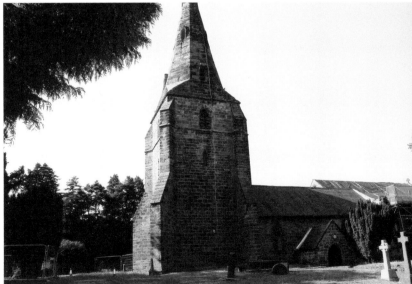

Above left: Broached spire of St Andrew's Church.

Above right: St Andrew's from the churchyard.

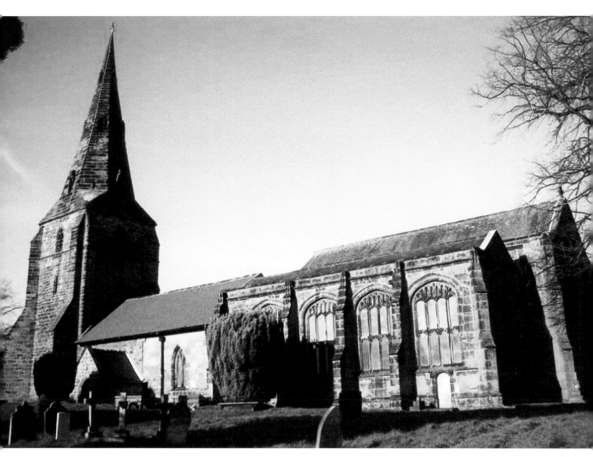

St Andrew's from the north.

the chancel'. The church, as it stands today, consists of the usual arrangement of nave and chancel. What is rather less customary is that both elements have north and south aisles, all of different periods, which makes the evolution of the church difficult to discern. There are a set of three misericords in the stalls: a bearded man, a dolphin and a pelican in her piety, a representation of sacrifice and resurrection.

23. Lady Lever Art Gallery, Port Sunlight

Known as the 'Jewel in the Crown of Port Sunlight', the Lady Lever Art Gallery was designed in 1913 as a memorial to Lever's wife, who died the same year. The building was entrusted to the firm of William and Segar Owen, who had been responsible for many of the fine buildings put up in the village since 1888. Construction was severely delayed due to the First World War and not completed until 1922. The structure is of reinforced concrete with plastered interiors and

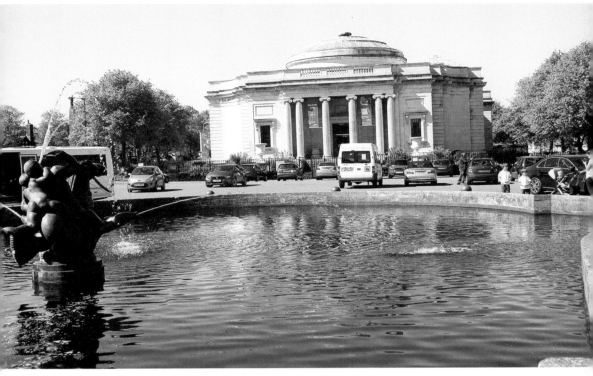

Art Gallery from King George's Drive.

an exterior finish of Portland stone. There are entrances on all four façades with fluted Ionic columns, and domes above the north and south entrances.

The guiding light behind all this, of course, was William Hesketh Lever, later Lord Leverhulme, who had felt the need to provide decent housing for his workforce and thereby created Port Sunlight village, so named after the main source of his wealth – Sunlight Soap. Port Sunlight had been conceived as an informal village, with workers' houses designed by numerous architects, including John Douglas and Edwin Lutyens, in varying styles. The formal setting of the Lever Art Gallery was therefore at odds with the original concept, which is why Lever insisted that it was not to be a tall building – so not to overpower the existing fabric.

Designed in the beaux arts style popular at the time, the gallery was primarily designed to hold Lever's large collection of art treasures, which included paintings by Turner, Constable, Reynolds and Gainsborough, together with an impressive range of Pre-Raphaelite works by Rossetti, Burne-Jones, Holman Hunt and Millais, the latter's painting *Bubbles* being shamelessly used to advertise Lever's soap. There are also fine collections of porcelain, glass, furniture and statuary.

A monument to Viscount Leverhulme was erected in 1930 to the west of the gallery by J. Lomax Simpson in a rather fascist-looking idiom and surely superfluous in this location – '*si monumentum requiris, circumspice*'.

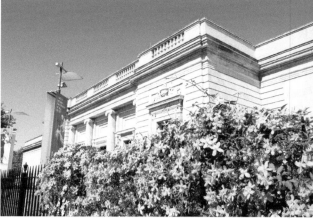

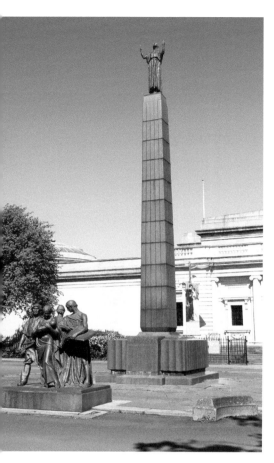

Above: Art Gallery from the west.

Left: Monument to Lord Leverhulme.

24. Hulme Hall, Port Sunlight

Hulme Hall, taken from the maiden name of Lord Leverhulme's wife, was built by one of Lever's preferred builders, W. & S. Owen, between 1900 and 1901, in Bolton Road, Port Sunlight, adjacent to the first ever cottages built in the village. It is an ornate single-storey building of brick and stone, with picturesque mullioned and transomed windows. Constructed originally as a women's dining hall with attached kitchens and room for 1,500 diners, Hulme Hall quickly became a popular venue for special functions of all kinds. When canteens were built within the main factory close by, the original purpose of the hall was lost and it was converted into a museum and art gallery. Lever considered enlarging it for this purpose before deciding on the construction of the Lady Lever Art Gallery, with George V setting in motion the foundation stone from Hulme Hall in 1914.

During the First World War it was used as a military hospital and as a centre for Belgian refugees, and did so again in the Second World War before being

Hulme Hall from Bolton Road.

Western entrance to Hulme Hall.

commandeered by the US Army as a billet for American troops dealing with ammunition ships at the nearby Bromborough Docks. Although the villagers did not know it at the time, the hall was to play host to the biggest band in the world in 1962 when the Beatles played four gigs there, including one for the esteemed Port Sunlight Horticultural Society and one at the Works Bowls Club Dance. The second

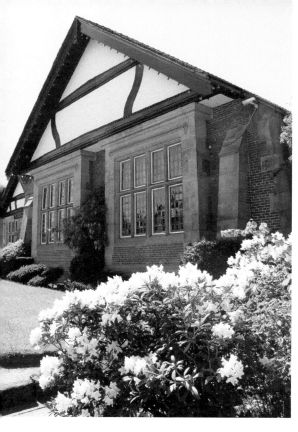

East gable of Hulme Hall.

of the four appearances, on 18 August, saw the official debut of a new drummer by the name of Ringo Starr who went on to superstardom with the rest of the group and later became the narrator of the *Thomas the Tank Engine TV* series. Prior to their final appearance on 27 October, the Beatles did a seven-minute interview with Monty Lister for Radio Clatterbridge, a local hospital station. This was the band's first ever radio interview and was done without the express permission of Brian Epstein, the group's manager, who apparently was not best pleased when he found out.

25. Gladstone Theatre, Port Sunlight

Gladstone Hall, as it was originally called, was the first institutional building to be erected in Port Sunlight. It was built as a recreational hall and men's dining room by William and Segar Owen in 1891, just three years after the first houses were put up in nearby Bolton Road. The hall was officially opened by William Ewart Gladstone, four times Liberal prime minister and close friend of William Hesketh Lever. Apart from the main dining area, smaller rooms were set aside for male and female clerks to have their lunch away from the hoi polloi. The central space was adorned with Pre-Raphaelite paintings from Lever's own collection to inspire and incentivise the workforce, and a large picture of Gladstone's Welsh mansion, Hawarden Hall was hung at the back of the stage in honour of the great statesman.

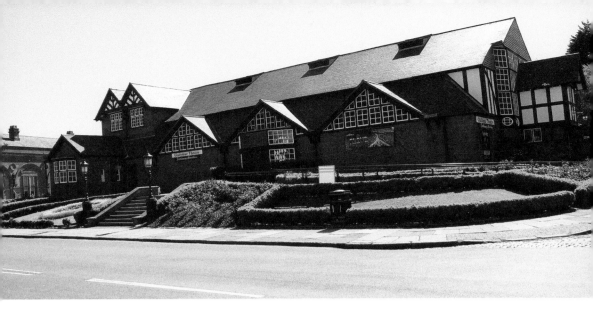

Above: Gladstone Hall from Greendale Road.

Right: Plaque to William Gladstone.

Unlike the women's dining room at Hulme Hall, there were no kitchen facilities. The men brought their own food in lunch baskets, so when a canteen was built within the factory this function ceased and the hall was given up for lectures by Lever, no doubt with a copy of Samuel Smiles' *Self Help* tucked under his arm. Evenings were taken up with various concerts, a function that it retains to this day with various music concerts and plays. With the advent of lighting, a larger stage and seating for 500 people, the hall changed its name to the Gladstone Theatre and holds regular performances by the in-house Gladstone Players.

The building itself is rather quirky with random gables and dormers dotted about; three of the gables contain large expanses of fenestration, which is most unusual. It is partly tile-hung, partly half-timbered and wholly charming. The final word is best left to Lever himself, who said it was 'the most appropriate village hall we have. It is simple and unpretentious, admirably adapted for the purpose for which it was designed, and most suitable and appropriate for erection in a village'.

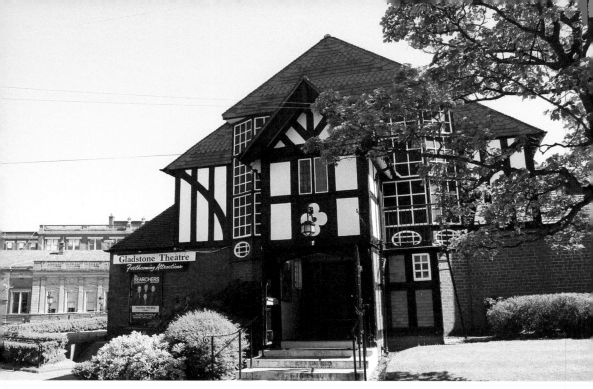

Entrance to Gladstone Hall.

26. Bromborough Pool

In 1847, William Wilson and Benjamin Lancaster formed a joint stock company in London manufacturing candles – not from the normal tallow, but from higher quality palm oil. They called their concern Prices Patent Candle Company, creating the fictitious Edward Price as the figurehead for the firm. The product was a great success and within four years the partners were looking for a site for their new factory. Wilson's two sons, George and James, decided on an area on the east of the Wirral Peninsula where land was cheap but also close to Liverpool and a ready supply of raw materials. As the factory was some way from existing residential areas, the brothers created Bromborough Pool Village to house their workers. This was one of the earliest examples of English private company philanthropy, predating the larger and far more well-known Port Sunlight village by over thirty years.

The first thirty-two houses were constructed in York Street in 1854, followed by a further sixteen in Manor Place in 1856, together with four larger residences for the managers on the green. A second phase in 1872–80 saw a further twenty-seven houses put up in Manor Place, with a final phase in 1896–1901. The workers' houses were built in terraces, but unlike the grotesque slums being created in nearby Liverpool, each house was constructed to a very high standard with front and rear gardens, three bedrooms, a living room, scullery and, extremely uncommon at the time, running water.

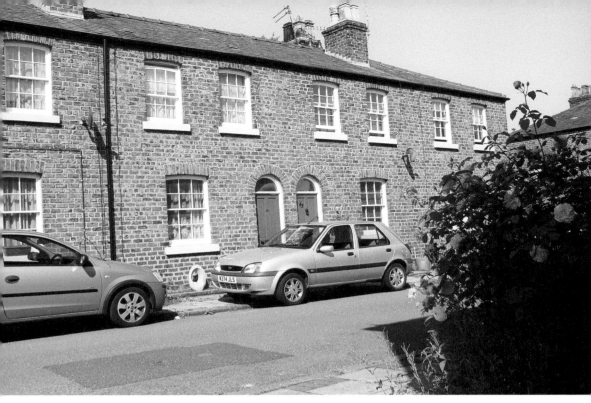

Above: Terraced housing in Manor Place.

Below: Bromborough Pool School.

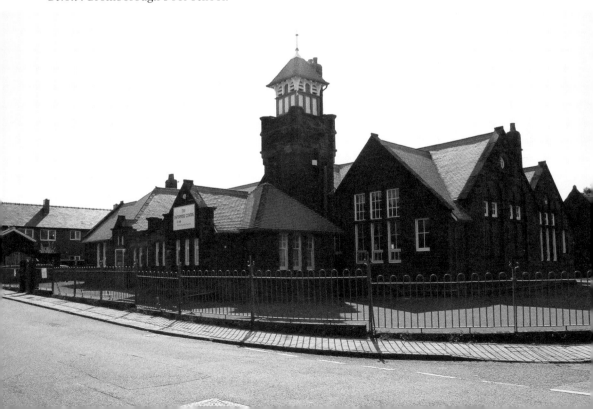

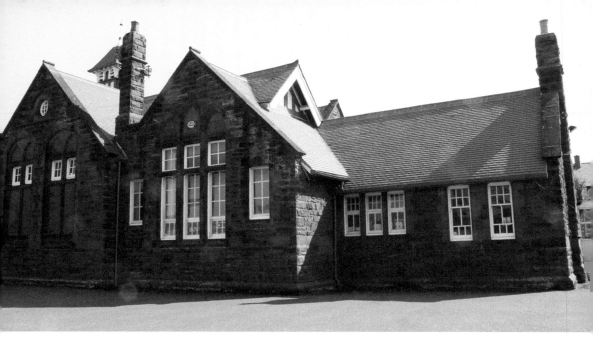

York Street Church.

Communal facilities were also provided. Schooling was initially catered for at No. 5 York Street until a purpose-built school was constructed for the workers' children. Made to an Italianate design, it now functions as the village hall. A fever hospital was unfortunately deemed necessary when over twenty villagers died of diphtheria. A larger hospital was set up in 1903, which now houses a social club, the original fever hospital being demolished in 1918. The village was declared a conservation area in 1984 and most surviving buildings were listed in 1986.

27. Hoylake Railway Station

With its internal cantilevered shelters, low flat-topped drum housing the booking hall and its overall art deco appearance, Hoylake railway station is by far the most architecturally ambitious buildings on the Wirral line of the Merseyrail network. The building seen today was constructed in 1938 of concrete with brick cladding in the same year as the electrification of the line by London Midland & Scottish (LMS). Designed by William Hamlyn, the adjacent footbridge is contemporaneous and also has an art deco feel. The station was powerfully influenced by Charles Holden's superb designs for the London Underground, such as Southgate and Chiswick Park.

The original railway line of 1866 only ran from Hoylake to Birkenhead Docks (now Birkenhead North station), with an extension through to West Kirby being forged in 1878. It was not until 1888 that a link was cut through to the Mersey railway, allowing passengers to travel to Liverpool, although they still had to change onto the Mersey Line at Birkenhead Park. It was only in 1938 when Hoylake station was completed that trains started to run directly to Liverpool.

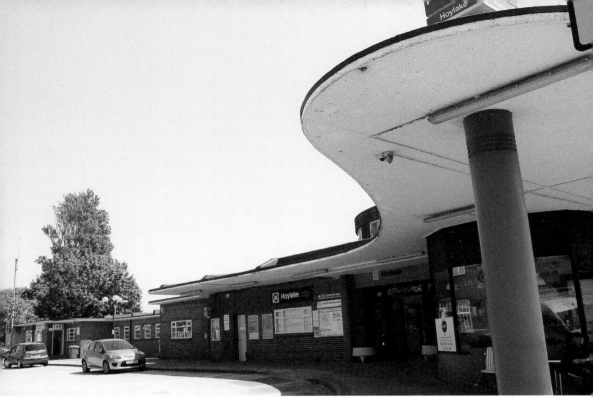

Hoylake railway station.

28. St Bridget's Church, West Kirby

While the earliest records of St Bridget's Church date back to the Norman period when the estate was sold in 1080 to the Abbey of St Werburgh in Chester, the church dedication suggests the existence of a pre-Conquest building – St Bridget being a well-known saint in the Celtic period. The church is of local sandstone with slate roofs and consists of a nave with north and south aisles, and a chancel with a north aisle, which, unusually, is not in line with the nave. Most of the oldest surviving work is medieval and can be found in the east and west ends. A series of heraldic shields over the west doorway alternate with rose-like ornamentation, the meaning of which is unclear.

Much early work was destroyed in an overzealous restoration undertaken in 1869–70; a further restoration in 1876 added the north porch. Fortunately, the early sixteenth-century embattled west tower survived relatively unscathed. Despite the destruction wrought when the church was practically rebuilt, the contribution of Charles Kempe at this time is to be admired. He created most of the extant stained-glass windows, including a depiction of St Bridget herself, along with some beautiful iron chancel screens and a painting above the chancel arch. The altar is constructed from reused wood taken from the roof of Chester Cathedral and the organ dates from 1893. There are interesting head stops representing Queen

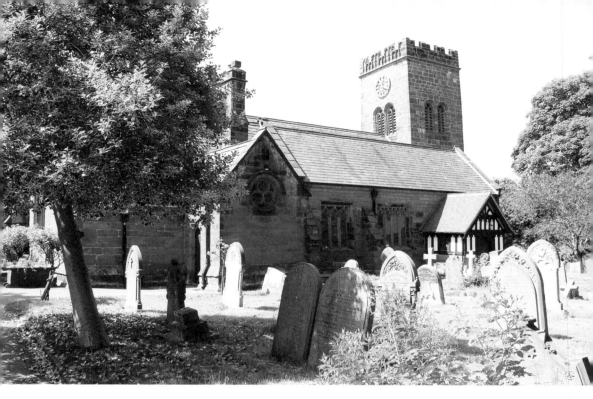

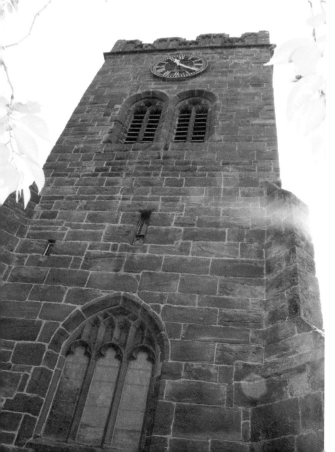

Above: St Bridget's Church from Church Road.

Left: St Bridget's Church tower.

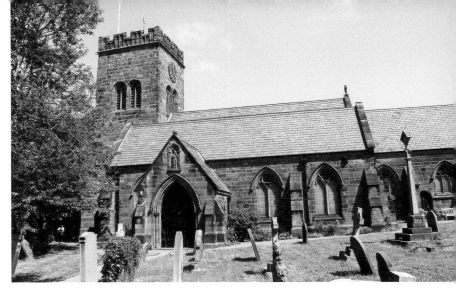

St Bridget's from
the south.

Victoria and William Jacobson, one-time Bishop of Chester, and a pair of gargoyles
bearing likenesses of W. E. Gladstone and Benjamin Disraeli.

Although the font inside the church dates from the nineteenth-century
restoration, a sixteenth-century font was dug up from the rectory garden in
1893 and is now in the nearby Charles Dawson Museum, which is also well worth
a visit as it contains many early artefacts, including an extremely rare hogback
tombstone made from stone not local to the area. The churchyard is entered
through a lychgate and contains much of interest, including eleven Commonwealth
war graves – nine from the First World War and two from the Second.

29. Hillbark, Frankby

Travelling along Vyner Road South in Birkenhead today the featureless stretch
of grey stone wall curving towards Ford Hill is easy to miss. Beyond this wall,
however, once lay Bidston Lodge, described by the noted architectural historian
Nikolaus Pevsner as 'one of the most notable essays in half-timbered design
anywhere in the country'. There is nothing to see here now, of course, apart from
the remaining small entrance lodge to the north with its elaborate chimney stacks
and pargetted walls. This is because between 1928 and 1931 the entire mansion
was dismantled and moved to Royden Park in Frankby, every stone and beam
being meticulously numbered to aid rebuilding.

Bidston Lodge was built in 1891 for the soap manufacturer Robert William
Hudson. The architects were Grayson and Ould, who also designed and built
much of Port Sunlight for fellow soap baron William Lever. It was shipping
magnate Sir Ernest Royden, however, who bought the property in 1921 and set
about moving it to his 250-acre country estate in Frankby. This mammoth task
took three years, but clearly Sir Ernest thought it worthwhile. The new bucolic
setting was far more to his liking, and he was proved correct in his assumption that

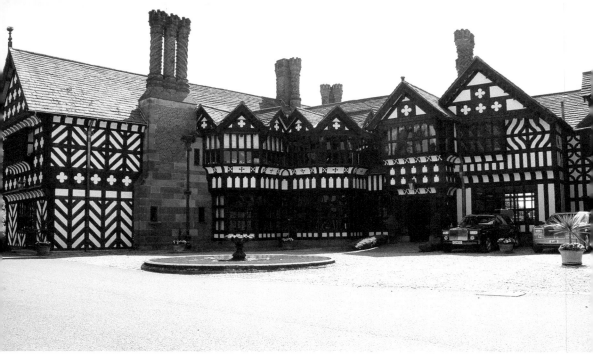

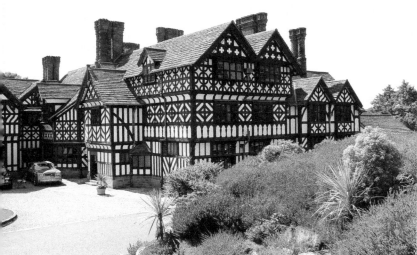

Above: Courtyard, Hill Bark.

Below: Hill Bark, south of the courtyard.

the view from the original site would depreciate as it now looks out over housing estates, high-rise flats and the M53. Once rebuilt, it was renamed Hillbark.

The mansion has a stone base from which rises a beautiful display of timber framing, set off with imposingly tall barley-twist chimney stacks. The main façade is of a U-shaped plan with a courtyard and centrally placed fountain, which all adds to the drama. The interior is just as impressive and includes materials brought in from other parts of the country, including a fireplace from Sir Walter Raleigh's house in Devon in the Great Hall, and a Robert Adam fire surround in the dining room. There is stained glass by William Morris & Co., along with many other Arts and Crafts features. After many years as a retirement home it is now a hotel.

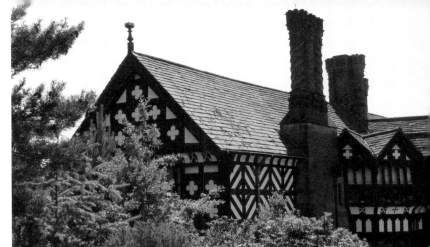

Barley-twist chimneys
at Hill Bark.

30. Irby Hall

There are over 6,000 moated sites known in England, the majority of them in
the south of the country. This makes the site of the current Irby Hall unusual,
particularly as it is constructed within an exceptionally large moat earthwork,
formed in the eleventh century to protect a manor and courthouse belonging to
St Werburgh's Abbey in Chester. This site, and a similar one in Bromborough,
testifies to the abbey's dominance and control of this area of Wirral in medieval
times. The whole area around the moat is a scheduled Ancient Monument,
although the east side is no longer visible as it is now under Irby Road. Recent
excavations have established the existence of an Iron Age settlement in the area,
with some evidence of even earlier activity dating from the Bronze Age.

Irby Hall.

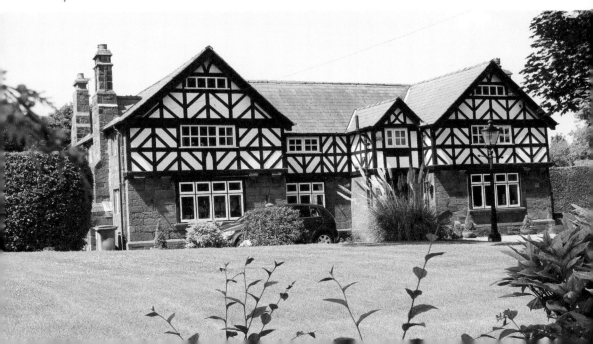

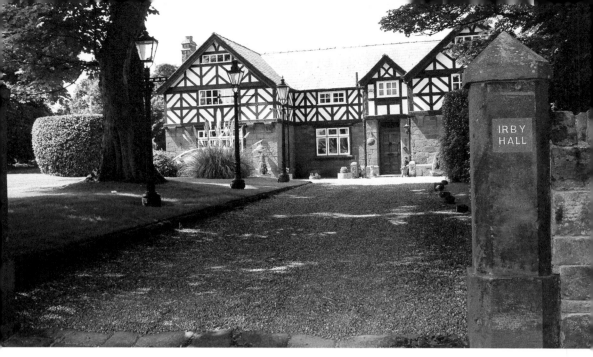

Entrance to Irby Hall.

The hundreds court for the whole of the Wirral Peninsula was held here for many years before the Dissolution of the Monasteries by Henry VIII relieved the monks of their property in 1535 and the land was appropriated into the hands of the laity. After a series of owners the hall came into the possession of the Irby branch of the ubiquitous Glegg family.

The present house dates from the early seventeenth century and is of red sandstone with a slate roof, two storeys with four bays and black-and-white timbering, which would have initially been coloured brown with earth-coloured infill. There is a huge chimneypiece to the north façade. After falling into decay a major restoration was undertaken in 1888; the entrance façade dates from this time. Again becoming derelict, another restoration was undertaken by John Anderson in 1971, and happily the hall is still in an excellent state of repair today.

The public footpath running between Irby Hall and the Anchor Inn was once used by mariners from the village who left their boats at the nearby anchorage at Dawpool. The Old Hall looks a little out of place in modern Irby, but is none the worse for that.

31. Thurstaston Hall

One of Wirral's oldest houses, Thurstaston Hall was built around the time of the Norman Conquest on a moated site to protect it from marauders from nearby Wales, although very little of the original fabric remains. An architectural historian recently identified a possible medieval room in the west wing, the oldest part of the hall, dating from 1300–50.

The hall was given to Robert de Rodelant ('of Rhuddlan') by Hugh Lupus, Earl of Chester, in 1070. Following Robert's death, the family took the name of the village. Thus started an unbroken chain of related owners, with the estate passing from the Thurstastons to the Heswalls through marriage and likewise through to the Whitmores, a family of Chester merchants who were incumbents from 1360 to 1832. A central block was added in 1680 that bears a date stone inscribed 'WWD1680'. An eastern range followed soon after the Gleggs of Backford took over in 1832, built in a pleasing Elizabethan style with the usual mullions and dormers.

The main entrance is flanked by a Grade II gateway with flanking Corinthian half-columns and a broken pediment containing the arms of the Whitmores. There are fluted pilasters on the gate piers and a date stone of 1733. All this disparate work has happily blended together over time and groups well with the adjacent St Bartholomew's Church, giving 'a charming appearance, tranquil and mellow'.

Such a rambling pile would not be complete without a ghost, and Thurstaston Hall is no exception. During a stay at the hall by the esteemed Royal Academician William Easton, an apparition of an old woman appeared to him, wringing her hands and seemingly looking frantically for something. It transpired that a member of the Whitmore family had murdered her infant child, and her ghost was looking for the knife used in the foul deed. The spectre returned on subsequent nights and Easton eventually managed to sketch a likeness of the woman. Miraculously, this drawing still exists.

Nearby stood Dawpool, built by Norman Shaw for Thomas Ismay of the White Star Shipping Line. It was shamefully destroyed by dynamite in 1927 as it was 'surplus to requirements'.

Thurstaston Hall.

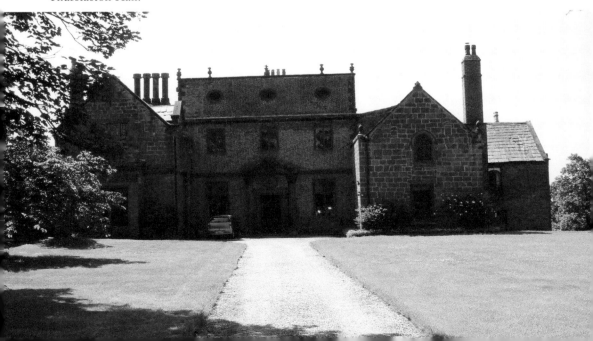

Gateway to Thurstaston Hall.

32. Brimstage Hall and Tower

Tucked away off the main road from Clatterbridge to Heswall in the village of Brimstage lies a tower attached to Brimstage Hall, one of the oldest buildings extant on Merseyside. Documents survive of a request by the Hulse family to build an oratory on the site in 1398. Most of the fabric of this building remains with us today. At the base of the tower is a vaulted room thought to have been used as a private chapel, in the corner of which lurks a corbel in the form of a grinning animal. It is said to be the original Cheshire Cat, but more prosaically it may be a heraldic lion, which was a device used by the Domville family who once owned the property.

There is much speculation as to the true purpose of the tower. It has been suggested that it was a peel tower on which fires were lit as a warning of approaching danger. There is evidence, however, that the tower may have been part of a larger structure, which would preclude its use as a beacon. Another theory is that it was a fortified tower, as the upper part has machicolations that could have been used to pour molten metal or boiling water on any unfortunate attackers below. The original third storey has been altered and now has a pitched roof and a staircase containing garderobes – a primitive type of toilet.

The property has had many owners over the centuries, including Lord Leverhulme and Sir John Talbot, whose descendants became the earls of Shrewsbury. Margaret, one of the earl's daughters, is reputed to have thrown herself from the top of the tower after being disappointed in love. Her ghost, in a white dress, is said to haunt the corridors of the hall.

Today the site is called Brimstage Hall and Courtyard, and makes an unusual shopping village, selling various craft goods and local produce.

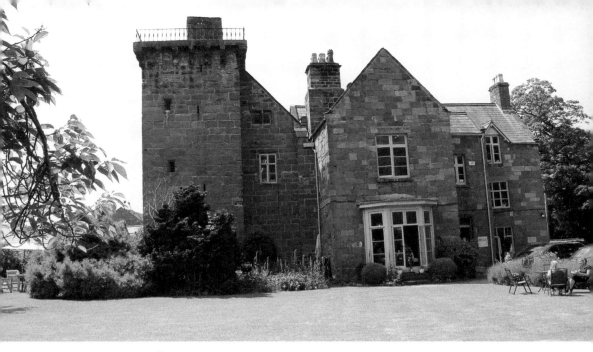

Above: Brimstage Hall and Tower.

Below left: Brimstage Tower from the south.

Below right: Brimstage Tower from the east.

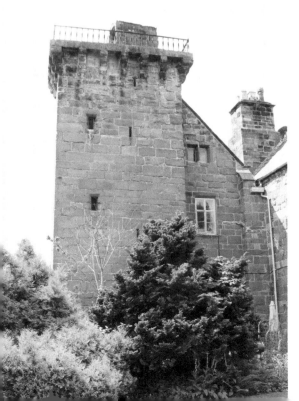

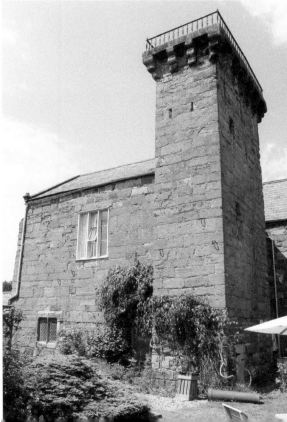

33. Thornton Manor

Built on land originally owned by the Mostyn family of Wales as part of their vast Parkgate estate, Thornton Manor was constructed in the middle of the nineteenth century on a rather modest scale. It was owned by the Forwood family and it was Sir William Forwood, chairman of the Liverpool Overhead Railway, that first leased the property to its most famous occupant, William Hesketh Lever, in 1888, before selling it outright to Lever in 1893. The viscounts Leverhulme were to remain at the manor for over a century, with the property being sold on the death of the 3rd Viscount in 2000 – this included all of the fine furniture, which fetched a record price at auction.

Once in ownership, Lever set about enlarging the mansion, mainly with a view to housing his large and ever-expanding collection of artworks and furniture. The ground-floor rooms are all in differing styles to act as settings for his various collections, including the French Room and the Adam Room. He also had Chinese-style cabinets made to show off his fine collection of chinoiserie. Douglas and Fordham of Chester were responsible for the main alterations of 1896, most of which were removed or remodelled less than twenty years later by Lomax-Simpson. Stables and a kitchen block were added in 1899, and the large Music Room with its fine Wrenaissance interior in 1902. The main gatehouse leading to the entrance forecourt was added in 1910, and further wings in 1913. The large ballroom was later converted into a swimming pool. One of the more unusual aspects of the house is Lever's own bedroom, which was open to the elements; it is said that he sometimes woke up with snow on his bed. He also had an outside bath in which to immerse himself.

Thornton Manor from the west.

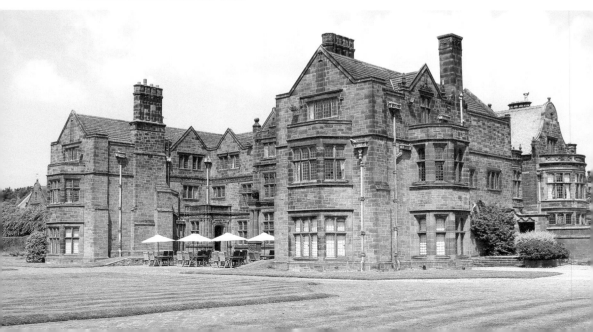

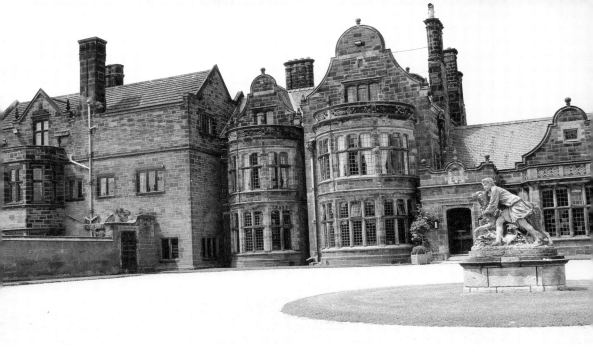

Thornton Manor from the courtyard.

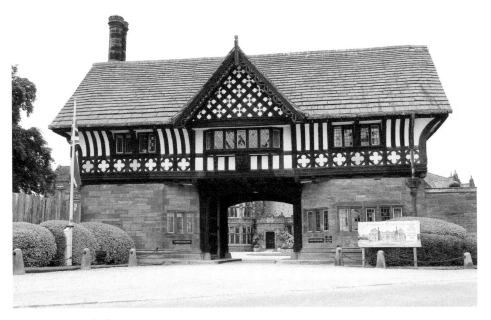

Main entrance lodge.

There are extensive grounds, including wooded paths, a summerhouse, a bridge and a substantial lake. Over 5 miles of tree-lined avenues were planted by Lomax-Simpson in 1912–14 as part of a much wider but only partially realised scheme to improve travel between Lever's dispersed estates. The property is currently a hotel.

34. Hinderton Hall

Set in 51 acres adjacent to the busy A540, Hinderton Hall is a rather attractive mid-Victorian mansion in a pleasant parkland setting. What is far more important, however, is the architect of this villa. It is a very early work by the prolific Liverpool architect Alfred Waterhouse, who designed this property before his first major commission, the Assize Courts in Manchester, a wonderfully ornate Gothic building in the centre of Manchester that sadly no longer stands, having been bombed in the Second World War. He went on to design the Natural History Museum in London, Manchester Town Hall and Liverpool University among many others.

Hinderton Hall was built for Christopher Bushell, a Liverpool wine merchant and local politician who helped found the Liverpool River Police. When he took up residence he quickly busied himself getting involved in local charity work and one of his main benefactions was to create a healthy water supply for the people of Neston, who duly thanked him by erecting a fountain in the town centre bearing his name. The hall is of rock-faced sandstone with ashlar quoins and dressings, and a steeply sloped roof in patterned slate – a motif that would be one of Waterhouse's most common features as his career flourished. He was also responsible for all three lodges on the estate, a handsome stable block and even created a sandstone dog kennel, which still exists.

Sir Percy Bates, one-time chairman of the Cunard Shipping Line, bought the hall in 1907 and built extensions onto the property, thankfully in keeping with the original fabric.

The Rees family subsequently purchased the hall in the 1980s and built a chapter house for their own use, also in keeping with Waterhouse's Victorian Gothic style, using old bricks and stonework sourced from a redundant church in Ellesmere Port.

Hinderton Hall.

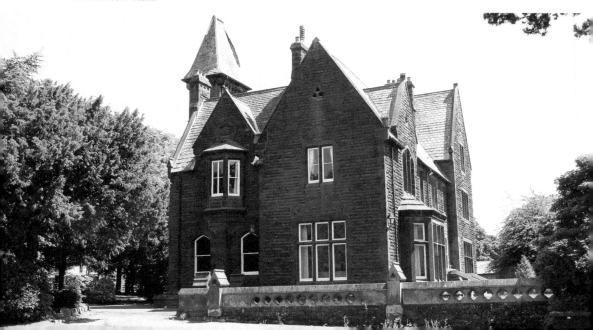

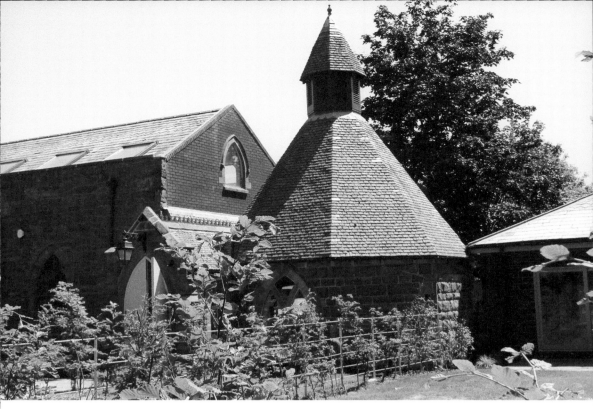

Above: Hinderton Hall stable block.

Right: Hinderton Hall from the west.

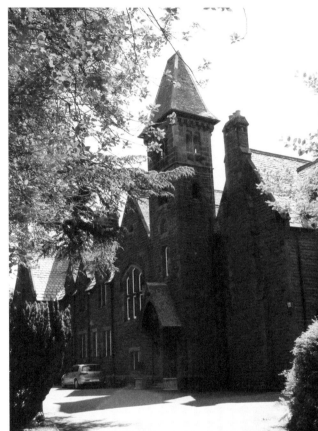

35. The Wheatsheaf, Raby

Claimed to be Wirral's oldest public house, The Wheatsheaf in the village of Raby is probably the worst-kept secret in the Peninsula. Despite it being tucked away down a small country lane, its reputation for good food and real ale make it an extremely popular watering hole for locals and tourists alike. The current building was constructed in 1611, the date stone having been discovered in the gable during alterations. However, this replaced an even earlier building that was burnt to the ground. Legend has it that a girl called Charlotte died in the conflagration and continues to haunt the pub.

'The Thatch', as it is colloquially known, is a single-storeyed, half-timbered, whitewashed structure of a type commonplace on Wirral until the 1800s. The interior boasts very old high-backed settles in the main bar, tiled floors, low oak beams and real fires. It has been extended at the back by converting an old shippon into a dining area appropriately called the Cowshed, all in keeping with the original fabric. The Wheatsheaf is located just off Raby Mere Road and became a Grade II listed building in November 1962.

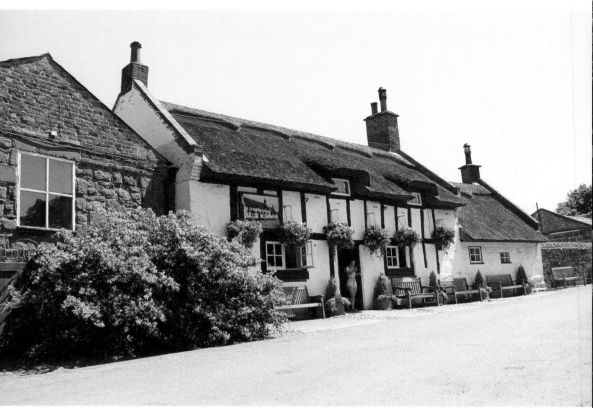

The Wheatsheaf, Raby.

36. Mostyn House School, Parkgate

In 1855, Edward Price was looking for a new site for his expanding preparatory school in Tarvin, a small village in Cheshire. The location he selected was on the front at Parkgate overlooking the River Dee and boasting magnificent views over to North Wales.

His school incorporated an existing pub called The George, which dated back to 1779. When he transferred the school into the stewardship of Algernon Sydney Grenfell in 1862 it began an unbroken run of 150 years of ownership by the Grenfell family. They quickly set about enlarging the property, taking full advantage of its prime position by constructing large windows to the south-west range, including an impressive Diocletian window, which has survived intact. Halls, a masters' house, swimming pool, kitchens and a separate belfry building were added over the years, all to such a high quality that when it was listed as Grade II in 2011 Historic England were moved to note that what remained formed 'a complex of landmark buildings with a high level of architectural distinction and flair that were designed to convey and reflect the high standards of its educational provision'. High praise indeed.

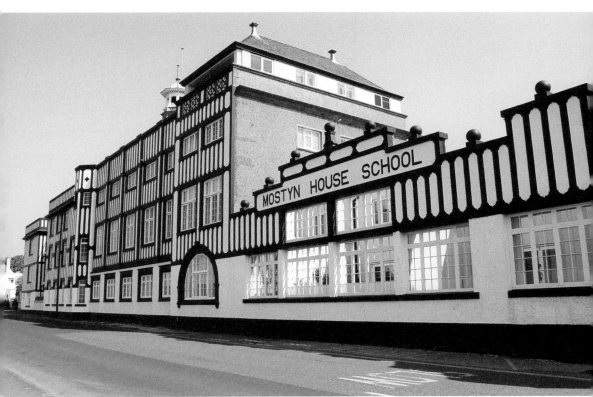

Mostyn House School from the Parade.

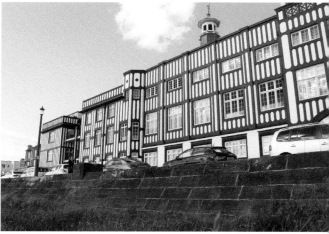

Above: Mostyn House School from the Marsh.

Left: Diocletian window on the west elevation.

Algernon Grenfell's son Wilfred was born in the school in 1865 and found fame as 'Grenfell of Labrador'. As a qualified doctor he devoted his life to the Eskimo's, establishing hospitals, orphanages and schools. During one hair-raising adventure he was rescued from a drifting ice floe after three days, surviving by skinning his three dogs and using the pelts to keep warm. There is a plaque in the school chapel to 'Three brave dogs, Moody, Watch and Spy, whose lives were sacrificed for mine'. It is doubtful if the dogs were particularly brave; they probably had little choice in the matter.

The distinctive black-and-white façade of Mostyn House School dates from 1932 when part of the front wall was in danger of collapsing and needed to be strengthened. Ten years later a large air-raid shelter was built under the playing field. It could accommodate 100 boys and their teachers and was used after the war as an indoor sports hall. The school closed in 2010 when it was bought by a property developer and converted into flats.

37. St Winefrede's Church, Neston

Tucked away on the side of the road from Neston to Burton, this quiet and unassuming little unlisted church would be worthy of little note were it not for the fact that it was designed by one of the greatest of all Victorian architects, Augustus Welby Northmore

St Winefrede's Church.

Pugin. Largely responsible for the Gothic Revival of the early 1830s through his books as well as his architecture, Pugin designed a number of magnificent Victorian Gothic churches such as Grade I listed St Giles in Cheadle, and was the designer of much of the Palace of Westminster in collaboration with Sir Charles Barry.

As the parish of Neston expanded in the early 1840s, the principal landowner, the Earl of Shrewsbury, commissioned Pugin to build a church for the increasing congregation. It was built as part of a group, including a presbytery, parish hall and school, and arranged around a churchyard. It is one of several similar-sized churches designed by Pugin at this time and is one of the two oldest catholic churches in Wirral – the other being St Werburgh's in Birkenhead. It was extensively altered in 1994 and as a result lost its listed status.

38. St George's Church, Thornton Hough

Thornton Hough is usually thought of as the archetypal Leverhulme village, with its picturesque vistas and Tudor Gothic architecture. Lever, however, was a comparative latecomer as the village is of pre-Conquest origin. It is mentioned in the Domesday Book as 'Torintone', its current name being established when the daughter of the landowner, Roger de Thorneton, married Richard de Hughe during the reign of Edward II (1307–27).

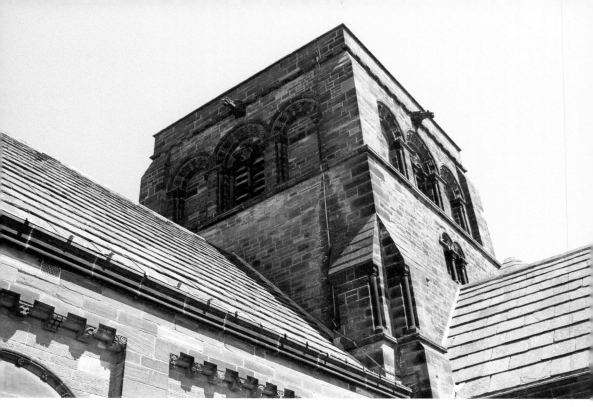

Crossing Tower of St George's Church.

The village expanded during the tenure of Joseph Hirst, a wealthy woollen mill owner from Yorkshire. He was responsible for All Saints, the large church above the green, and nearby Wilshaw Terrace. When Lord Lever made the decision to move to nearby Thornton Manor he set about building another church to the west of All Saints in a neo-Norman style that reflected 'Levers love of richness in architecture and dignity in worship'.

Designed by J. Lomax-Simpson, who had already done much work for Lever in Port Sunlight, it is of sandstone with a stone-flagged roof, of cruciform plan with a five-bay nave and a broad central tower containing a recessed pyramidal roof and robust stair turret. The interior is of ashlar with a rib-vaulted apse containing blind arcading, which is also present in the richly adorned crossing arches. Each window is treated differently and each is extremely elaborate. The capitals are enlivened with biblical scenes, including Noah's Ark and Sampson in the Temple. The altar contains a vibrant frieze and marble-columned arcading; the pulpit and font are both of imported Caen stone. Parishioners could never be bored within this space, no matter how dull the sermon may be.

The impressive architecture continues outside with an extravagant hexagonal, covered entranceway, also designed by Lomax-Simpson and again neo-Norman. Approached by a small flight of steps, each rounded arch is powerfully detailed; the heavy buttresses at each angle, however, look a little too bulky. Lever also contributed a school, a social club and the village shop with its landmark turreted corner, making Thornton Hough one of the most striking villages in Wirral.

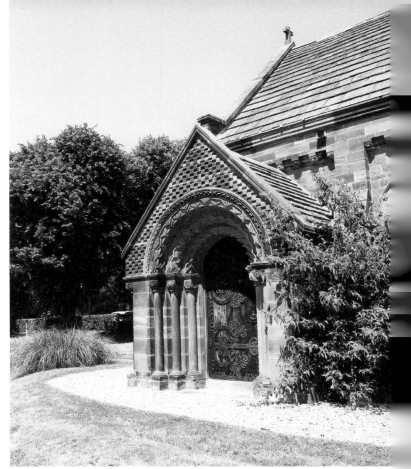

Right: Neo-Norman south porch.

Below: Covered entranceway to St George's.

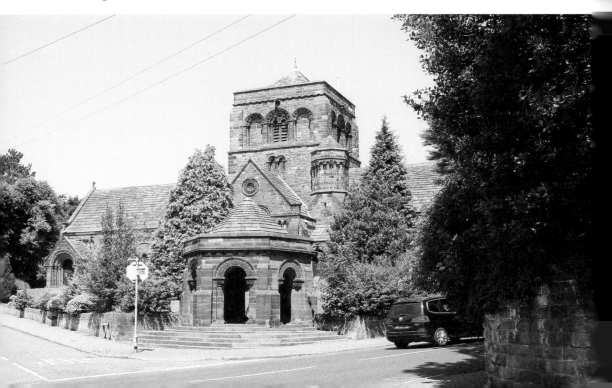

39. Stanhope House, Bromborough

The Spann family built a house on the present site of Stanhope House in Tudor times, with records dated 1554 indicating that George Spann, a gentleman of Bromborough, was the proud owner at this time. The fine building occupying the site today, however, was built in 1693 by descendants of George called Joseph and Elizabeth (their initials appear above the main doorway), leading the building to be originally named Spanns Tenement.

The current structure is of sandstone with slate roofs. Sturdy drip moulds adorn the mullioned windows and attic dormers containing small bulls-eye windows, a most unusual feature. Much use was also made of reused carved stone taken from demolished buildings throughout Bromborough village.

Stanhope House was bought in 1937 by local builder A. H. Boulton, who kindly offered it to Bebington Council. The council ran it as a library from 1939 until 1967 when it was allowed to be vandalised, deteriorating to such an extent that demolition was considered. Luckily intervention by the Bromborough Society halted the decay, allowing Raymond Richards of Gawsworth Hall in Cheshire to eventually take it on and restore it to its former glory, even bringing in exquisite old panelling from Chillingham Castle.

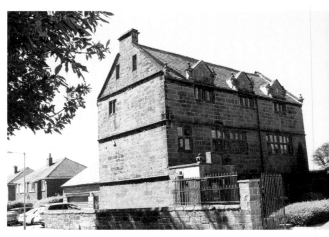

Above: Stanhope House.

Left: Gable end of Stanhope House.

40. St Mary's Church, Eastham

There has been a church in Eastham since at least 1087 when the Domesday Book mentions a priest at Eastham. The current church was built by Earl Randall of Chester in 1150, originally as a chapel to the mother church of St Barnabus in Bromborough, but there is evidence of a Saxon chapel on the site. It has been enlarged and renovated in practically every century since then: some of the north wall is Norman, the nave is mainly thirteenth century, the tower fourteenth century, the aisles fifteenth century and the south porch sixteenth century. The tower was rebuilt in the eighteenth century when the broached spire and unusual gable pinnacles were created.

Victorian restorations were undertaken in 1863–64 by John Douglas of Chester, who restored the chancel, followed by a major restoration by David Walker in 1876–80.

The entire church is built in stone and consists of a four-bay nave with north and south aisles, and a chancel to the east with a vestry to its north and the famous Stanley Chapel to its south, designed in medieval Perpendicular style. There are

Below left: St Mary's Church, Eastham.

Below right: Broached spire of St Mary's.

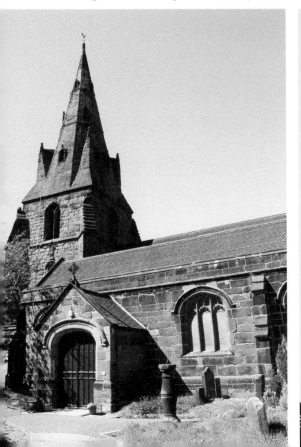

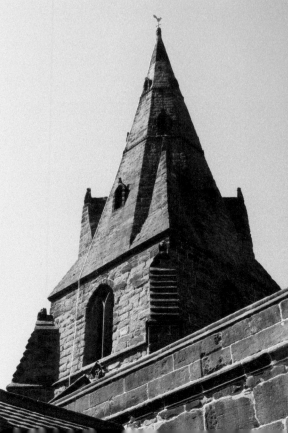

St Mary's Church lychgate.

two large altar tombs: one of alabaster commemorates Charlotte, Lady Stanley, who died in 1662; and a sandstone tomb to Sir William Stanley, who died in 1612. There are also various other memorials to the Stanley family on a less-grand scale. Much of the stained glass was created by Charles Kempe in the nineteenth century.

All this antiquity, however, pales against the vast age of the celebrated yew tree in the churchyard, which by some estimates is around 1,200 years old. It is mentioned in 1150 when the villagers of Eastham appealed to the monks of St Werburgh's, Chester, to 'have a care of their old yew tree'. Also in the churchyard is a sundial dated 1798, which has been given a Grade II listing by Historic England, and a substantial war memorial for the fallen of two world wars.

41. Eastham Ferry Hotel

Standing on the main route from Birkenhead to Chester, Eastham was an important transport hub for many years. Coaches brought passengers down through the village to Eastham Ferry and thence to Liverpool – originally on sailing boats, which took half a day, but from 1816 via steam packets, which ran twice a day. The Eastham Ferry Hotel was constructed in 1843 by Sir William Stanley to cater for this expanding trade. It was to prove a judicious move as the area around the hotel, being of outstanding natural beauty, became a tourist attraction in itself.

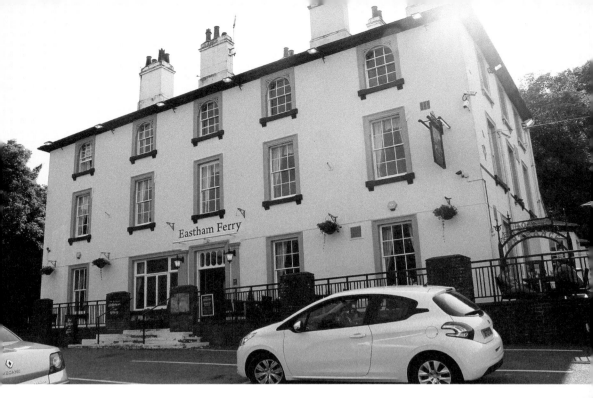

Above: Eastham Ferry Hotel.

Right: Old fountain in Eastham Woods.

 The hotel boasted eleven bedrooms, most with superb views across the Mersey to Liverpool. Nathaniel Hawthorne, the American consul for Liverpool, waxed lyrical at the time about the beauty of the place, the quality of the service and the peerless views. Richard Naylor, a Liverpool merchant, bought the hotel in 1846 and began to develop the area. Zoological Gardens were created, traces of which survive to this day, and included a bear pit and fountains. Unfortunately the magnificent entrance to the gardens, built adjacent to the hotel and designed as a Jubilee Arch, was demolished in the 1930s, ostensibly because it was unsafe but during demolition it proved to be perfectly sound.

Bear pit in Eastham Woods.

The hotel was catering for 1,000 visitors a day at this time, with further attractions arriving with each new season. A bandstand, a fairground with water chute and loop-the-loop rides were built, and circus acts were performed in the gardens, including exhibitions of derring-do by the famous tightrope walker Blondin. Less-savoury temptations were also on offer, such as the 'World's Fattest Woman', flanked by a pair of unsmiling dwarfs, a pickled man with two heads, and a tank of man-eating spiders.

All this activity gave the area the sobriquet 'the Richmond of the North', its popularity reaching its apogee after the First World War before declining rapidly in the 1920s. The Ferry was demolished in 1929 and the area fell into dereliction, although the hotel continued trading throughout this time. Salvation came in 1970 when the area was designated a country park, after which many improvements were made and the hotel was completely refurbished in 1978–79.

42. St Paul's Church, Hooton

The spiritual needs of the good people of Hooton were fulfilled for many years by the church of St Mary's at Eastham, which was quite a walk for the able-bodied of the parish, but practically impossible for the elderly and infirm. This situation continued until Richard Naylor, a wealthy Liverpool banker, purchased the nearby Hooton Hall from Sir William Stanley and set about building a church within the grounds of his newly acquired mansion. The site chosen was adjacent to the main gateway to Hooton Park, just off the main stagecoach route from Birkenhead to Chester, now part of the A41.

The architect chosen was James Kellaway Colling, and what he created for Naylor was one of the most spectacular churches in Cheshire. The unique design is a skilful combination of Gothic and Byzantine influences, laid in bands of white-and-red ashlar and rock-faced stone. It is cruciform in plan. The aisles are of three bays and lead into an octagonal crossing with transepts, continuing into an

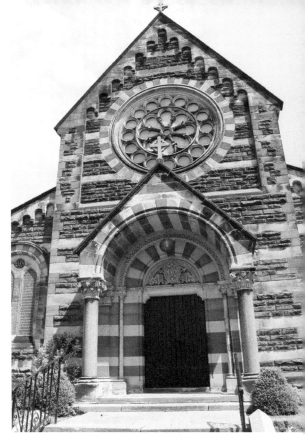

Right: Main entrance to St Paul's Church.

Below: Naylor family entrance.

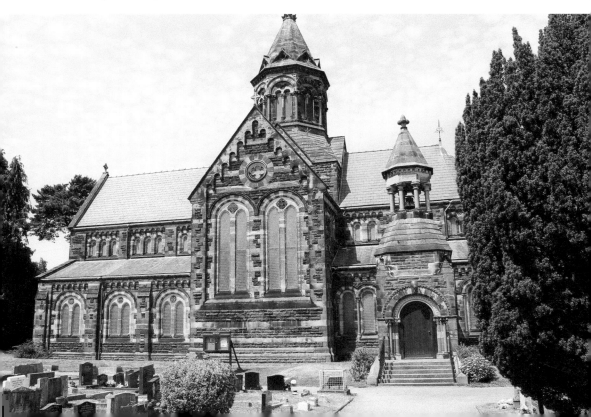

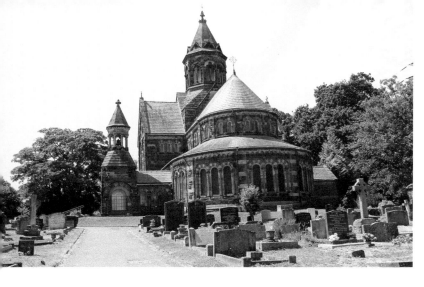

St Paul's from
the west.

apsidal end with an ambulatory containing some beautiful stained glass. Finally
there is a private entrance for the Naylor family with a truncated pyramid roof.

The church is entered through a porch placed centrally in the west façade below
a wheel window. This has the usual banded brick and stonework with a carved
tympanum above the door. This leads through to the interior of the church, which
is equally impressive, the great height being further augmented by the inside face
of the dome, continuing the banded theme of the exterior.

The building cost £5,000 and took four years to complete. The foundation
stone was laid in 1858 and the consecration by the Bishop of Chester was on
St Paul's Day, 25 January 1862. Before the church was built the site was part
of Eastham parish; however, a new parish of Hooton was created by combining
Childer Thornton, Great and Little Sutton, Hooton and parts of Whitby.

43. Willaston Old Hall

Willaston village can trace its history back to before the ninth century, deriving
its name from an Anglo-Saxon landowner called Wiglaf who owned a farm in the
vicinity – hence Wiglafs Tun. The community grew up around the village green, which
has an air of antiquity about it even today. Just to the east of the green in Hadlow
Road stands the impressive Old Hall of strawberry-red brick, with sandstone quoins,
mullioned and transomed windows, all on a base of sandstone blocks. Built in the
Elizabethan style to an 'E' (for Elizabeth) plan, it boasts three impressive full-height
square bays topped with gables, and a solid stone entrance porch.

It was thought for many years that the date of construction was 1558, but this
has been largely disproved by several architectural historians, including Nikolaus
Pevsner, who thought the date was far too early for the style of architecture. The
interior of the hall retains many original features, including old chamfered beams
and exposed joists, and ceiling-height oak panelling. The salient features, however,
are the two carved crests in the centre of the frieze. The larger of the two depicts
the arms of the Bennett family: 'Argent (silver), two barrs gules (red) with a bordure

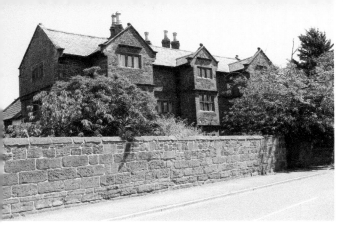

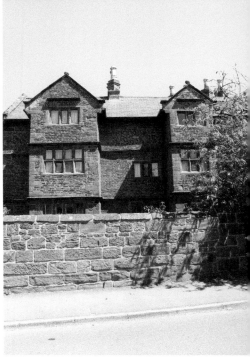

Above: Willaston Old Hall.

Right: Full-height gables at Willaston Old Hall.

(border) engrailed sable (black).' The smaller crest depicts a lion rampant (rearing up). The room containing these two crests was possibly used as a private chapel. The hall was most likely constructed by Hugh Bennett of Oxton between 1610 and 1620.

Although the Old Hall is often referred to as 'the Manor House', this has never been the case as Willaston has never had a lord of the manor; it is merely one of several lords' houses dotted around the village. A programme of much-needed repairs was undertaken after 1968 when a Dr Laurie bought the property with the help of grant funding for much of the restoration.

44. Hadlow Road Station, Willaston

Walking along the Wirral Way today it is not always apparent that it was once an extremely busy railway line, but every now and then architectural evidence comes into view. There are the remains of a platform at Thurstaston and a railway bridge here and there, but as you approach Willaston, preferably from the west, Hadlow Road station comes into view. One is instantly transported back in time to the 1950s, when life seemed so much more peaceful and leisurely. The memories will come flooding back to those of an age to remember such places, the station having been carefully and lovingly restored to how it would have been in 1956, the year of its closure to passengers.

The railway came to Hadlow Road in 1866 when the London & North Western Railway constructed a branch line off the main Chester to Birkenhead route, starting at Hooton station and travelling through Willaston and Neston to Parkgate. A further extension continued the line into West Kirby, creating nine

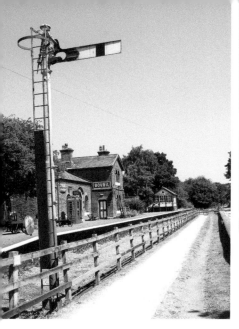

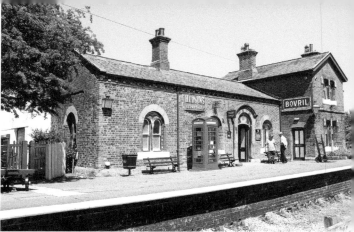

Above: Hadlow Road station looking east.

Left: Hadlow Road station.

stations in all. All this infrastructure opened up the area to markets and suppliers in the rest of the country – fish from Parkgate, coal from Neston colliery, milk and cheese from the many farms on the route – together with passengers, businessmen heading to Chester and Liverpool, day trippers to Parkgate and the beach at West Kirby. Up to twenty-four trains were using Hadlow Road in its heyday.

All this activity sadly declined after the First World War as the colliery closed, Parkgate silted up and the upturn in road traffic all put pressure on the railway. The line finally closed to passengers in September 1956 and to freight in May 1962, just four years short of its centenary. Due to the foresight and campaigning zeal of Captain Lawrence Beswick and others, the route of the railway, apart from a short stretch that had already been sold for housing, was converted into the UK's first linear park and was opened to the public in 1973.

Hadlow Road is a living museum, complete with ticket office, signal box, level crossing gates and a section of the original railway line below the platform. On a quiet day there are few more evocative places.

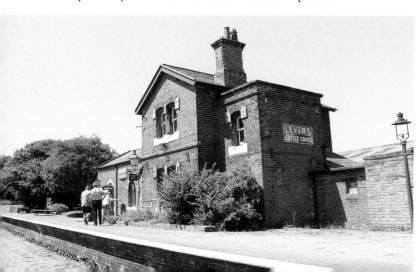

Hadlow Road station looking west.

45. Church of the Holy Trinity, Capenhurst

Holy Trinity is one of the finest examples of Gothic Revival ecclesiastical architecture in Wirral. The architect responsible for this delightful church was James Harrison, who was also responsible for many of the black-and-white buildings of Chester. His main claim to fame is his restoration of God's Providence House, Watergate Street, in 1862, which is claimed to be the first case of conservation in the modern sense. Construction began in 1856, with the consecration three years later.

The main body of the church is of red sandstone with ashlar dressings and consists of a four-bay nave and two-bay chancel at a lower level. In 1889, John Douglas, who also did much work in Chester, created the steeple to the west of the nave consisting of a three-stage tower with corner buttresses, and a further timber-framed stage topped with an unusual-shaped broach spire. He also added an octagonal stair turret at the south-west corner and a clock commemorating the coronation of Edward VII. Douglas also reordered the interior, which contains an impressive stone reredos with the Ten Commandments in an Arts and Crafts style.

Below left: Broached spire of Holy Trinity.

Below right: Holy Trinity Church, Capenhurst.

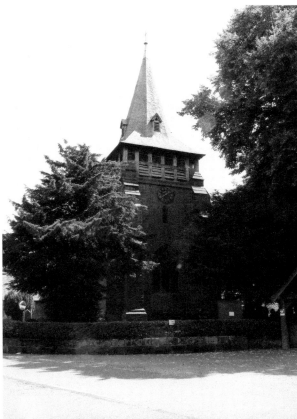

46. Ellesmere Port Lighthouse

In 1791, a group of prospective canal speculators met at the Royal Oak in Ellesmere to discuss a route for a new canal they wished to build from Shropshire to the River Mersey in order to transport their wares to the expanding Lancashire port. As this was the era of canal mania, funding was not a problem and the waterway was duly built by their chosen engineer – William Jessop. The link to the Mersey was to be 'at or near Netherpool', at which point the town of Ellesmere Port was born.

With the canal proving to be a success, Jessop's subordinate, Thomas Telford, was tasked with improving the facilities at the Ellesmere Port terminus. This involved the purchase of land from Earl Grosvenor – hence the origin of local street names such as Grosvenor Street and Westminster Road. Along with china clay warehouses and additional wharves, a lighthouse was constructed in 1880 adjacent to the harbour master's office. Known as Whitby Lighthouse, its primary function was to guide barges into the Shropshire Union Railways and dock complex – roughly where the Ellesmere Port Boat Museum now stands. It was also an aid to navigation for vessels wishing to enter the basin from the Mersey, where they could load and unload in the main dock to the west or the inner dock, adjacent to the canal, as its light was visible for over 19 miles.

It is situated on the north pier above the Whitby Locks. Designed by G. R. Webb, it is a tall red-brick octagonal tower 36 feet high with an unusual harebell roof. It was to lose its raison d'être in 1894 when the Manchester Ship Canal

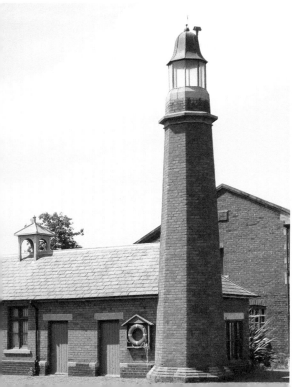

Left and opposite: Ellesmere Port Lighthouse.

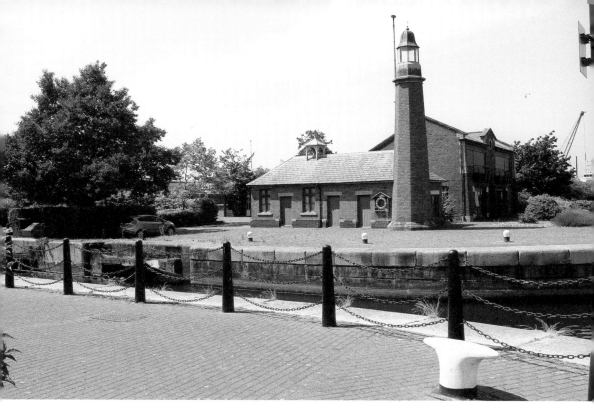

opened, thereby cutting off direct access to the Mersey at this point – the new canal entrance now being over 3 miles downstream at Eastham Locks.

The lighthouse and harbour master's office next door are both now listed buildings but unfortunately are not open to the public; however, they can be viewed from the south side of the original entrance.

47. Barn End Cottage, Burton

Burton is possibly the most picturesque village in Wirral, having an abundance of Grade II listed buildings. To select just one from such riches may seem a little arbitrary, but Barn End Cottage does stand above most, especially as it is perched above the street on its own sandstone outcrop. Built around 1450, it is an example of a cruck-framed structure. This involved joining two naturally curved timbers on either side of the building, forming an A shape, which would then be fixed by a horizontal beam between the two. While this form of construction was very popular in the Middle Ages, the demand for naturally curved timber became too great as they were required for the construction of ships for the Royal Navy and their domestic use gradually died out.

Barn End Cottage was originally a pair of cottages, but is now a single dwelling. It is constructed of sandstone blocks and brick noggin, which has all been rendered and whitewashed to give a more uniform appearance. It has a thatched roof and

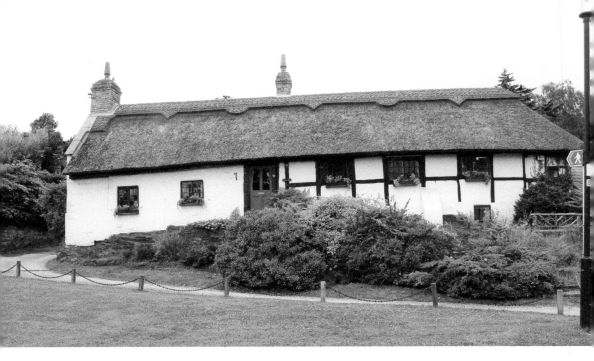

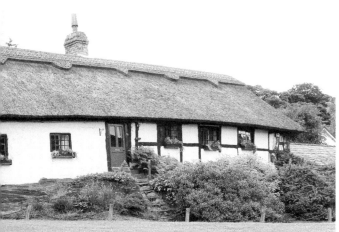

Above: Barn End Cottage.

Left: Barn End Cottage from the village.

is approached by a set of ten steps cut into the sandstone ridge. The interior of the cottage reveals the cruck trusses in the partition walls of the bathroom and one of the bedrooms, and there are old doors and exposed ceiling timbers throughout the property.

Although Burton village has no public houses today, at one time it boasted five, including the Coach and Horses, the Royal Oak and the oddly named Earth Stopper. Another was located in Barn End Cottage, formerly called the Fishermans Arms. It was later known as Noah's Ark, but also had the nickname of 'the Robbers Den', perhaps a reference to an illicit smuggling trade from a time when the Dee had more prominence than today. The beer cellar was hewn from the sandstone ridge below the cottage.

48. Burton Manor

The Congreve family were major landowners in the Burton area throughout the eighteenth and nineteenth centuries, at a time when it was possible to demolish lesser mortals' properties on the slightest pretence. This is precisely what they did when they required a 'gentleman's residence' in the village: ten workers' cottages were demolished in 1805 to make room for Burton Hall. This fine house remained in the Congreve family until the entire estate was purchased in 1903 by Henry

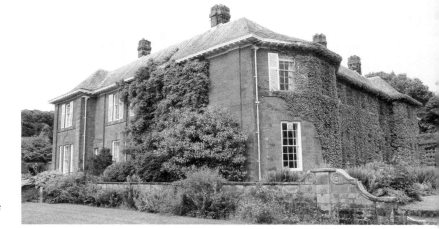

Right: Garden front of Burton Manor.

Below: North façade of Burton Manor.

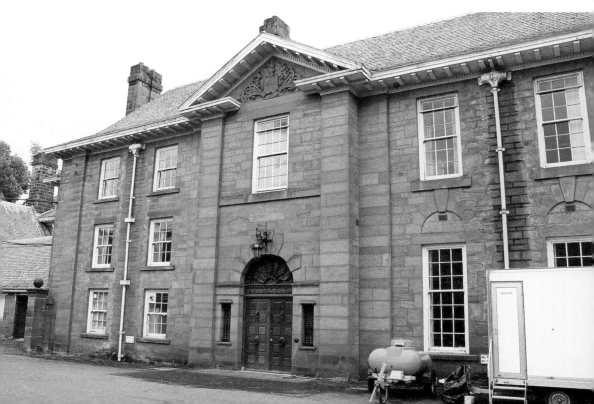

Neville Gladstone, the third son of William Ewart Gladstone, four-times Liberal prime minister and also a major landowner, having his country seat just across the Dee at Hawarden.

H. N. Gladstone practically rebuilt Burton Hall and renamed it Burton Manor, and this is predominantly the building we see today. The grand entrance is on the north side and bears the Gladstone coat of arms, which includes the head of a black man – a stone manifestation of the derivation of a large part of the Gladstones' wealth. Extensions included the building of a library, music room, billiards room and twenty-seven bedrooms. At the core of the building is a small internal yard called Fountain Court with a fine ground-floor loggia – the original fountain unfortunately has not survived. Two lodges were built in the grounds, together with a coach house and an icehouse. One of the most attractive aspects of the manor, however, is the gardens, created over several seasons by Thomas Mawson, who was introduced to the Gladstones by William Lever. The noted Victorian architect Arthur Beresford Pite also worked on the manor; he is responsible for the orangery, which he constructed in 1910.

After William Glynne Gladstone tragically died in action in the First World War, the family decided to move back to their Hawarden mansion. In 1924 the manor was purchased by property speculators, who let the property out until it was compulsorily purchased by Liverpool Corporation and converted to a residential adult learning college. It is now in the hands of a restoration company, its ultimate fate uncertain.

49. Backford Hall

Arguably one of the most delightful old halls in Wirral, Backford Hall is clearly not to everyone's taste. The famous architectural historian Nikolaus Pevsner thought it wildly 'over-egged' and 'debased'. It is described less brutally by Historic England as being in exuberant Elizabethan and Jacobean Bohemian Rococo styles with red brick and diaper work, quoins and dressings. Whatever one's point of view, it is difficult to ignore.

Built on the site of two previous houses, the hall was designed by John Cunningham in 1863 for a member of the famous Glegg family of Wirral – Edward Holt Glegg. The Gleggs were landowners on the Peninsula for centuries and had branches of the family in Irby, Grange and Gayton, with Gayton Hall being their main residence. The famous Glegg Arms was named after them and they were also involved in the founding of Calday School.

The hall has forty rooms, a galleried hall and ornamental ceilings, with a lodge, stable block and barn built within the 24-acre site. Bought by Cheshire County Council for a mere £10,000 in 1946, it was subsequently sold to a property developer in 2011 for several million pounds, and the hall was converted into ten luxury apartments.

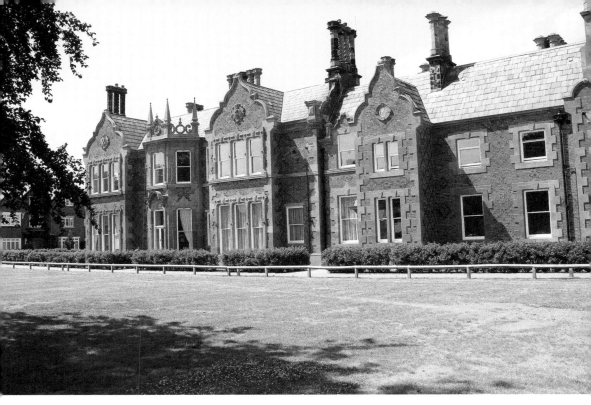

Above: Backford Hall from the garden.

Below: North façade of Backford Hall.

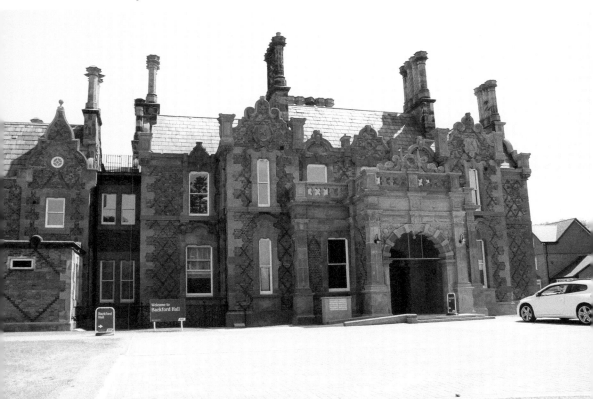

50. St Michael's Church, Shotwick

History has moved on from Shotwick. It is difficult to imagine that this shopless, publess, sleepy backwater of Wirral was once a military strongpoint where the armies of two English kings set off to conquer the Welsh. What is now a dead end to the west of the village used to lead to a major ford in the River Dee, which led directly over to Flint where Edward I built one of his notorious ring of castles, including the more famous Conwy Harlech and Caernarfon bastions. The vicars were known as the Chaplains of the Ford. All this activity made Shotwick the most important village on the west side of Wirral, which in turn led to the building of St Michael's Church – St Michael being the patron saint of soldiers.

Although mention is made of a church here in the Domesday Book, the church we see now is essentially twelfth century in origin with fourteenth-century alterations. The tower was added in the sixteenth century and it underwent the usual Victorian restoration in the nineteenth century.

It has two parallel naves, which is unusual for an English church but quite common in Wales. Entry is gained through the one surviving decorated Norman doorway in Wirral: a heavily studded wooden door is flanked by a stone porch that contains a series of deep scratches, said to have been made by archers sharpening their arrows against the stone. Similar marks can be found at Holy Cross in Woodchurch and no doubt in other churches of this date. The porch has been used as a schoolroom and later as a place to solemnise marriages.

The interior oozes history, with items worthy of note being a set of wooden box pews, a rare churchwardens pew dated 1673 and a three-decker pulpit against the north wall.

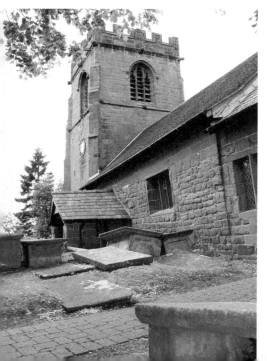

St Michael's Church, Shotwick.

Above: Arrow marks in the south porch.

Below: St Michael's from the south.

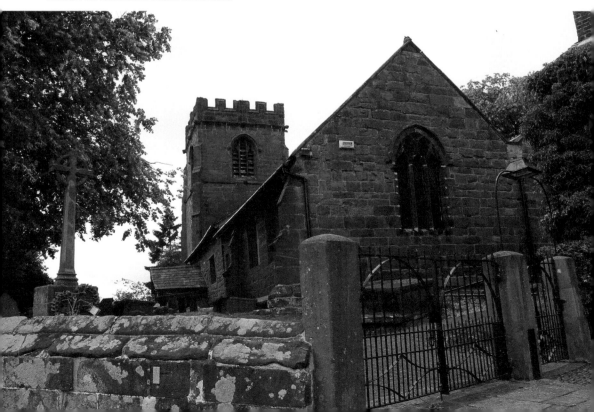

About the Author

Les Jones was born in Wallasey when it was still part of Cheshire, where the whole of the Peninsula truly belongs. Educated at Oldershaw School and John Moore's University in Liverpool, he has taken a keen interest in both architecture and local history for many years. He has been married to his wife Deborah for thirty-five years and has three grown-up sons, Andrew, Christopher and Daniel, and four beautiful grandchildren to whom this volume is dedicated. This is his second book for Amberley.